Just in Case

Just in Case

**EVERYONE'S GUIDE
TO DISASTER PAREDNESS
AND EMERGENCY SELF-HELP**

by
John Moir

Copyright © 1980 by John Moir.
All rights reserved.
Printed in the United States of America.

Library of Congress Cataloging in Publication Data

Moir, John.
 Just in case.
 1. Civil defense. 2. Assistance in emergencies.
3. Survival and emergency equipment. I. Title.
UA926.M64 363.3'5 79-28435

Book and cover design by Brenn Lea Pearson.
Composition by Hansen & Associates.

Chronicle Books
870 Market Street
San Francisco, CA 94102

*To Ellen
and the rest of my family*

ACKNOWLEDGEMENTS

I would like to express my appreciation for the assistance received from the following organizations in gathering information for this book: American Gas Association, American Red Cross, American Waterworks Association, Boston Public Schools, California State Office of Emergency Services, Dade County Public Schools, Edison Electric Institute, Federal Communications Commission, Los Angeles Unified School District, National Oceanic and Atmospheric Administration, Pacific Gas and Electric, Pacific Telephone, Pajaro Valley Unified School District, Ray-O-Vac Division of ESB Inc., San Francisco Unified School District and Union Carbide Corporation.

In addition, my thanks to Jeff Merrill, Sharlya Gold, Dr. Robert Roth, and my brother Jim for their aid and suggestions. I am very grateful for the contribution Jeanne Herrick made in helping to edit the manuscript. And finally, my deepest gratitude to my wife Ellen whose love, patience and assistance helped immeasurably.

TABLE OF CONTENTS

Introduction		ix
Section 1	**How to Prepare for a Disaster**	**1**
Chapter 1	Disaster . . . What to Expect	3
Chapter 2	Getting Help	11
Chapter 3	Lighting the Way	25
Chapter 4	Tuning in the Outside World	32
Chapter 5	Understanding Your Utilities	40
Chapter 6	A Complete Guide to Fire Extinguishers and Smoke Detectors	55
Chapter 7	Storing Food and Water	69
Chapter 8	Hightailing It—How to Evacuate	76
Section 2	**If the Time Ever Comes**	**87**
Chapter 9	Heavy Weather	89
Chapter 10	Fire!	111
Chapter 11	Earthquakes and Tsunamis	122
Chapter 12	The Unthinkable Disaster: Nuclear Accidents and Weapons	135
Chapter 13	Blackout!	147
Section 3	**What to Do Following a Disaster**	**153**
Chapter 14	Water—The First Priority	155
Chapter 15	Protection from the Elements	163

Chapter 16	Staying Healthy—Preventing Disease and Filling Your Stomach	173
Chapter 17	Easing Your Mind	179
Section 4	**First Aid in a Disaster**	**187**
Chapter 18	Preparing a First Aid Kit	189
Chapter 19	Quick Reference Guide to First Aid	194
Appendices		**211**
Appendix 1	Resources	213
Appendix 2	Kids, Schools and Disaster	221
Appendix 3	State Emergency Planning Offices	231
Index		**239**

INTRODUCTION

Just In Case is designed to serve as your guide to disaster preparedness and emergency self-help. In it, you'll find the skills, plans, tools and information you need to cope successfully with most disasters. This is not a wilderness survival manual—it won't tell you how to snare wild animals or search out underground springs in the desert. Instead, it provides the practical knowledge you need before, during and after a disaster.

My own experiences in Hurricane Camille, and during the San Fernando Earthquake gave me a first-hand understanding of the critical nature of disaster preparedness. Being self-sufficient and knowing what to do in a time of crisis is of utmost importance to you, your family and your community. *Just In Case* contains the information and directions you need. It is my sincere hope that armed with this knowledge you'll be able to react with confidence in the face of a disaster.

The rest is up to you. It's going to take a little time and money to get prepared, but the end result—your safety and security—is the payoff. Once the initial effort is completed, you can tuck this book away in a handy location where it will always be available to serve as your passport to safety—just in case.

John Moir
Santa Cruz, California

SECTION 1

HOW TO PREPARE FOR A DISASTER

CHAPTER 1

Disaster . . . What to Expect

The Atlantic and Gulf Coasts, September, 1979 — Within just two weeks of each other, a pair of powerful hurricanes swept up through the Caribbean and slammed into the U.S. The first storm, named David, packed winds of over 150 miles per hour. It hit hard at several of the Caribbean islands before swinging up the Atlantic coastline. Over three hundred thousand residents fled low-lying areas as David battered coastal regions with torrential rains and strong winds. Within days, Hurricane Frederic followed David's path through the Caribbean, then swung west toward the Gulf Coast. More than half a million people hurriedly evacuated before Frederic churned into Mobile, Alabama with winds of over 130 miles per hour. As the evacuees from both storms returned home, repaired the damage, and settled back to normal life again, it was with the knowledge that next summer would once again bring the threat of new hurricanes.

New England, late February, 1978 — The first weeks of 1978 brought severe winter weather to most of the East. The hard winter culminated with a giant snowstorm that plowed into New

England with hurricane-force winds of over 100 miles per hour. The entire region was covered with snowdrifts deep enough to bury cars. At the height of the storm, one hundred thousand people were without electricity. Transportation and communication systems were paralyzed and food supplies ran short. Businesses, schools, and stores all closed until the storm ended. As winter-weary residents finally began to dig out, many realized that now was the time to make preparations for the next big one, as there was no telling when it would strike.

Northern California, late January, 1980 — A series of strong earthquakes and aftershocks rocked the San Francisco Bay area, cracking streets, toppling mobile homes, and disrupting phone service. At the Lawrence Livermore Laboratory, a nuclear facility in the area, a tank cracked, releasing radioactive water, and a multi-million dollar laser system was knocked from its supports. Although the worst of the quakes, registering about 5.8 on the Richter Scale, caused substantial damage, few people were injured. Perhaps the most disturbing aspect of the temblors was the prediction by many scientists that these quakes were only a mild example of what could happen. Many geologists expect a quake hundreds of times stronger than these to strike the area before the turn of the century.

Each of these three disasters touched the lives of hundreds of thousands of people. Those involved were faced with the sobering fact that disasters aren't always just an item on the television news. It is a disconcerting experience when suddenly *you* are the one struggling against a severe storm, groping about during a power outage, or hastily packing your belongings and heading for an evacuation center.

Consider these facts:
- Each year several million Americans are involved in a disaster situation.

- Each year several hundred thousand people are affected severely enough by a disaster to require the assistance of the Red Cross or other relief agencies.

- Each year scores of communities are damaged badly enough by disasters to need special financial aid and assistance from the government.

As much as we hope they will never happen to us, or to our families, emergencies and disasters are an inevitable fact of life. While we have little control over when an emergency may strike or whom it will involve, we *can* be prepared to meet the challenge when it does arrive. Disasters have a funny way of sneaking up just when they're least expected. An attitude of "it can't happen here" has left many people unprepared and ill-equipped to face the unfamiliar problems of an emergency. A positive and realistic approach to the ever-present possibility of an emergency entails doing what you can to reduce your vulnerability.

Along with the information and preparation necessary to minimize a disaster's impact, a calm, positive outlook is the extra ingredient that can improve many emergency situations. Anxiety is natural when people are faced with threatening or unfamiliar problems, but understanding what to do can work to alleviate some of this apprehension and help channel your energy in constructive directions. Being prepared to take the correct actions gives you the edge in helping yourself and others.

WHAT TO EXPECT IN A DISASTER

We are accustomed to a life of convenience that would seem unbelievable to someone who lived just a hundred years ago. And yet, the marvels of modern technology are often the first things to be swept away by a disaster. Many emergencies temporarily interrupt the electric, water, sewer, communication and transportation systems upon which our present way of life depends. When this occurs, we are left to grapple with unusual problems and difficulties.

It is vital to realize that help may not be rapidly forthcoming. No matter how well-organized the relief effort, it frequently takes from several hours to as much as a few days before help arrives and services are restored. Therefore, your ability to be self-sufficient is of critical importance. How well you fare depends largely on your plans, preparations and knowledge.

THE BASICS OF DISASTER PREPAREDNESS

1. *Planning And Preparation*—Most people spend hundreds of dollars each year on various forms of insurance. How many, however, have made the necessary preparations to develop their own "disaster insurance plan"? It's easier than might be imagined. The premium costs you some time and a relatively small outlay of money. The benefit you receive is the ability to safeguard your family and home from most disasters in the best way possible.

2. *What To Do In An Actual Disaster*—If a disaster strikes, you need to have good, solid

information on what to do. This means knowing about the disasters that may occur in your area, when they most often happen, and how to protect yourself from them. If you do much traveling, it's also a good idea to have at least a basic understanding of disasters that strike in other parts of the country.

3. *How To Handle A Disaster's Aftermath*—The critical time following a disaster, when public services are limited or non-existent, is likely to pose unusual problems. Having the knowledge to deal with these will make things easier and, in many cases, save needless worry and effort.

4. *First Aid*—You may have to rely on your own first aid skills during an emergency. To prepare for this possibility, you should have a first aid kit suited to your own particular requirements. Furthermore, the ability to give first aid in a disaster can be a lifesaver.

You can improve your expertise in all these areas by taking advantage of the various resources available in your community. Refer to Appendix 1 for a listing of books, periodicals and classes.

Your readiness in case a disaster strikes may well depend on a thorough understanding of the four basic areas of disaster preparedness. For easy reference, this book is divided into sections that correspond with these areas.

Emergency Supplies

Having the proper equipment on hand is often a decisive factor in an emergency. There is no better time than the present to invest in the

necessary equipment. While no one needs every item mentioned in this book, there are a few to which special consideration should be given. The eight most important items to have are:

1. Flashlight (see Chapter 3).
2. Battery-operated radio (see Chapter 4).
3. Fire extinguisher (see Chapter 6).
4. Smoke detector (see Chapter 6).
5. Emergency food and water (see Chapter 7).
6. Water purification supplies (see Chapter 14).
7. First aid kit (see Chapter 18).
8. First aid manual (see Appendix 1).

Your individual needs will determine other items you'll want to buy. For example, a person living in a two-story house will want to consider a fire escape ladder for their bedroom. Someone else residing in a mobile home in a tornado-prone area may need a weather radio for early warning. The cost of whatever emergency supplies you end up purchasing is small when you consider that most of them will last for many years. More importantly, their true value is measured by the lives and property they may save.

Many of the emergency supplies recommended in this book are available through large retail or discount stores. A catalog from one of these stores will give you a general idea of the price you can expect to pay. Nearly all the articles suggested are quite inexpensive. Be sure to check the prices—the cost may be less than you imagine.

GENERAL DISASTER PREPARATIONS

Regardless of where you live or what type of disaster you may encounter, there are some standard preparations you can make. The nine most important are:

1. Post a list of emergency numbers near your phone (see Chapter 2).
2. Fill out an Emergency Information Card and carry it in your wallet (see Chapter 2).
3. Locate your utility shutoff valves and switches (see Chapter 5).
4. Plan where to go in case of an evacuation (see Chapter 8).
5. If you have school-age children, be familiar with your school district's emergency plans (see Appendix 2).
6. Have a fire escape plan for your home (see Chapter 10).
7. Take a first aid class (see Appendix 1).
8. Keep your typhoid and tetanus immunizations up to date.
9. Keep this book in an accessible location.

Depending on the types of disasters that can occur in your area, there may be additional plans and precautions you wish to examine. For example, those living in earthquake country will want to refer to the appropriate chapter for specific information.

YOU *CAN* MAKE A DIFFERENCE

What sometimes stands in the way of proper disaster planning is the belief that there really

isn't much that can be done. However, people who have just been through an emergency are usually quick to point out just how important these preparations are. The fact that we can't predict exactly when or where a disaster may strike is all the more reason to take the necessary steps to be ready. These preparations can make a difference, perhaps a crucial difference, for you and your family.

CHAPTER 2

Getting Help

Often the single most important thing to do in an emergency is to call for professional help. But in a disaster situation communication can be difficult. If you need to get help it becomes essential to know how to summon it correctly. This chapter will furnish you with the information needed to get quick and effective assistance even in a difficult situation.

MAKING AN EMERGENCY CALL

There are three important steps to making an emergency call:

1. Knowing the best emergency service to call.
2. Conveying all the needed information quickly and accurately.
3. Taking the correct actions until help arrives.

1. Whom To Call

It is usually obvious when to call for the fire or police department. Medical emergencies are not as clear-cut and it is sometimes hard to know where to get help. Telephone operators, doctors, ambulance services, fire and police departments are all frequently called in medical emergencies.

12 Just in Case

They do not, however, all offer the same degree of assistance. Calling the correct emergency service will assure you of getting the best help possible without wasting precious time. Emergency services vary from place to place; thus, while the guidelines set out here hold true for most areas, it's worth checking with your local emergency agencies if you have any questions.

Phone companies throughout the U.S. are phasing in the all-purpose emergency number "911". If this number is in use in your area it's all that's needed for any emergency situation. The "911" line is solely for emergency use and should not be called for any other reason. Phone officials emphasize that "911" should be referred to as nine-one-one, never nine-eleven. They point out that some people may become confused if they think they need to dial a non-existent "eleven" on the phone.

If "911" is not available, the fire department is the best agency to call for a medical emergency. In most urban and suburban areas fire departments maintain well-trained paramedic units that provide rapid and highly competent rescue services. The fire department dispatcher will usually summon the nearest ambulance service as well. Fire departments normally have a quicker response time than an ambulance service since there are more fire stations than ambulance companies. Fire trucks also carry special tools for freeing accident victims and can provide other emergency equipment as well, such as generators or pumps.

In certain localities, particularly rural, the local ambulance service is the number to call for a medical emergency. This is especially true if the fire department is volunteer or very small and not trained to provide medical services. If you're uncertain what the fire department can do for

you, give them a call and ask. All emergency numbers should be posted by the phone. Use the cut-out page at the back of this chapter to write them on.

Whom Not To Call In A Medical Emergency
Don't call a doctor or the police; use the telephone operator only as a last resort. Doctors these days don't have much practice making house calls. In a medical emergency when time is of the essence, a doctor can't respond quickly enough, nor does he have the training or equipment that emergency personnel will be able to furnish. While police normally have some first aid training, they too lack the equipment and expertise of a paramedic crew. A telephone operator must refer an emergency call to the proper place, which consumes valuable time. The operator should be used only if it's not possible to get through to the proper agency. However, dialing the operator is useful for small children who do not know how to use the phone.

2. What To Say
An excited person tends to talk too fast and jump from one thing to the next. When making an emergency call, force yourself to speak calmly and slowly. Give the following information in this order:

1. State that there is an emergency and briefly describe what it is.

2. Give the telephone number you're calling from, your location, the nearest crossroad if you know it, and your name.

3. Provide any information the dispatcher asks you for.

4. Most importantly—do NOT hang up until the dispatcher tells you to. That way you can be certain he or she has all the needed information.

A common source of confusion with many calls is the actual location of the emergency. Merely giving the address doesn't help if there are several streets with the same name, as is the case in many towns. Also, be sure to state whether the address is a street, drive, park, circle, avenue, etc.

3. What To Do While Waiting For Help

It will take a few minutes after you make the call before help actually arrives, although those few minutes may seem like hours at the time. Until qualified medical help is at the scene, the responsibility for managing the situation is still yours. Here's what to do:

1. Provide as much support for the victim as possible. That means giving needed first aid within the limits of your training (see Chapter 19). Don't try to give first aid that can be handled better by the emergency crew. Keep the victim warm and comfortable and don't move him unless it's absolutely necessary.

2. Support also means giving emotional comfort. Be as calm and reassuring with the victim as possible. Try to keep your tone optimistic and positive.

3. If possible, have someone outside to flag down the emergency vehicle. This is a real help to emergency personnel even if the location is easy to find. With an address that is at all difficult to locate, it can be critical. Apartment complexes and office buildings sometimes have numbering systems that

seem to defy logic. It doesn't help anyone if emergency personnel have to waste time searching corridors for the victim.

PHONE LINES IN A DISASTER

The best rule of thumb is: Don't use your phone in a disaster unless there is a serious emergency that requires immediate assistance. It's very tempting to want to contact friends and relatives. Unfortunately, this ties up phone lines that are needed for true emergencies.

In the event that you do have to make a call, the first step is to see whether the phone lines are working. The phone system has reserve power supplies that will keep it functioning even if the electricity is off. If there is no dial tone it means the lines are down or the system is jammed from overuse. No phone system is equipped to handle more than a certain number of calls at any one time.

If phone circuits are under a heavy load it may take longer than usual to get the normal dial tone. Phone officials recommend waiting one to three minutes; if there is still no dial tone, hang up and try again in ten to fifteen minutes. Simply leaving the phone off the hook or making repeated short attempts will contribute to jamming the system. If the phone lines are overloaded the phone company may simply shut off a certain percentage of the lines on a rotating basis. Therefore, you may only get a dial tone some of the time. If you have an urgent call to make, keep trying periodically to see if the phone is back in service.

In a disaster, certain phone lines will be particularly important. The phones for doctors, hospitals, schools, emergency services and certain business and government agencies are all

examples. These "essential service" lines receive priority; they are the last to be shut down and the first to be restored to service.

POSTING EMERGENCY NUMBERS

At the end of this chapter is a page for emergency numbers, to be cut out and posted by your phone. A similar list should also be posted at work. Filling out these pages now will greatly enhance your ability to respond quickly and effectively to a wide variety of emergencies.

Most phone books have a page at the front listing emergency numbers. Some areas will have many small fire districts or substations, each with a separate number. Be sure to select the number that is best for you. Put "911" by both police and fire if this number is used in your area. "Other" is for an ambulance service if needed, or for any other number useful in an emergency. This list is intentionally simple. If everyone from the orthodontist to the veterinarian is on an "emergency" list it increases the likelihood of an error or misunderstanding in a time of crisis.

VITAL INFORMATION IN A MEDICAL EMERGENCY

Providing emergency personnel with important information can speed up diagnosis and treatment. An emergency information card and a medical identification tag (if needed) will make it easier to receive medical assistance.

Emergency Information Card
An emergency information card is included at the back of this chapter. This card will furnish

emergency personnel with essential data if you are unable to. Keep this card in your wallet or purse at all times. Children should also carry a card so their parents can be notified immediately in case of an emergency, as a doctor can do little to help until parental permission is granted.

Medical Identification Tag

If you have a special medical problem it's well worth wearing an inconspicuous medical identification tag. This bracelet or necklace will instantly identify special medical conditions to emergency personnel if you are unable to. Paramedics are trained to look for these tags, which alert them to conditions such as diabetes, epilepsy, drug allergies or heart problems. These tags are available through Medic Alert, an international, non-profit organization with over a million members. Medic Alert provides you with a stainless steel bracelet or necklace engraved with your particular medical condition. Each tag also carries your file number and the telephone number of the Medic Alert Emergency Answering Service. Emergency personnel or a doctor can call this number collect 24 hours a day and instantly get vital information about your health, the number of your personal physician and your nearest relative. A low, one-time fee covers both the tag and the telephone service for the rest of your life. Silver and gold tags are available at higher prices. To get more information on Medic Alert, write to:

> Medic Alert Foundation International
> P.O. Box 1009
> Turlock, California 95380

Medical identification tags are also available from many pharmacies. These identify your medical condition but do not provide the telephone services of the Medic Alert tags.

A FEW FINAL WORDS ON GETTING HELP

Most emergency services are supported by your taxes. Don't be reluctant to use them. A good policy to follow is: When in doubt, call. Any of the emergency personnel you might need would prefer for you to call too soon, when a problem is still simple, rather than wait until it's too late to help.

Getting Help 19

EMERGENCY PHONE NUMBERS

FIRE _____
(Phone number)

POLICE _____
(Phone number)

OTHER _____
(Name) (Phone number)

OTHER _____
(Name) (Phone number)

IN AN EMERGENCY

Give the following information calmly and slowly:

1. State there is an emergency and briefly describe the situation.
2. Give your telephone number, address, nearest crossroad and your name.
3. Do NOT hang up until told to do so.

Getting Help 21

EMERGENCY PHONE NUMBERS

FIRE _____
　　　　　(Phone number)

POLICE _____
　　　　　(Phone number)

OTHER _____
　　　(Name)　　(Phone number)

OTHER _____
　　　(Name)　　Phone number)

IN AN EMERGENCY

Give the following information calmly and slowly:

1. State there is an emergency and briefly describe the situation.
2. Give your telephone number, address, nearest crossroad and your name.
3. Do NOT hang up until told to do so.

EMERGENCY INFORMATION CARD

Filling Out The Card
Fill out the card and carry it in your wallet. Put the following information in the medical sections:

Special Medical Problems List any important medical conditions that emergency personnel should know about. For example, put "fainting spells" if you have had a history of them. If you have no major problems, then put "none".

Known Drug Allergies List any drugs to which you're allergic. Put "none" if you've never had an allergic reaction to a medication.

EMERGENCY INFORMATION CARD

My name is: _____

Home phone: _____

Address: _____
In case of emergency contact:

Name Phone

Name Phone
— — — — — — — — Fold Here — — — — — — — —
Special medical problems: _____

Known drug allergies: _____

Family Doctor: _____

Phone: _____

CHAPTER 3

Lighting the Way

One of the most common emergencies is a power outage. A blackout may occur from a failure in the electrical system, or it may result from a variety of disasters such as floods, fires and strong storms. No matter what causes the power to fail, a good emergency light will keep you from groping in the dark. This is particularly important following a disaster such as an earthquake, when the utilities may need to be turned off rapidly (see Chapter 5). An emergency light is also indispensable in seeing to dial an emergency phone number, escaping from a burning building, or in other nighttime emergency situations where you must have light.

FLASHLIGHTS

Everyone should have a dependable flashlight. An old bargain-bin special in the back of a desk drawer, with half-dead batteries, just doesn't qualify. Although many different types of flashlights are sold in roughly the same price range, they are by no means equal in performance. The manufacturer is of little importance—the essential element is the type of battery a flashlight uses.

Flashlight Batteries
Larger and heavier batteries have the longest storage life and the best performance. Flashlights generally use one of four sizes of batteries. From the smallest to largest these standard sizes are: "AA" (penlight), "C" cell, "D" cell, and six-volt lantern batteries. For emergency use, only "D" cell and lantern batteries are large enough to provide the power you need.

Three different types of batteries are sold: regular zinc-carbon, heavy-duty zinc-carbon, and alkaline. Alkaline batteries are the most expensive, but the cost is offset by their extended shelf life and their ability to keep a flashlight shining considerably longer than other types of batteries. As a rule, an alkaline battery will continue working at least twice as long as a regular zinc-carbon battery when a flashlight is used intermittently. Under constant use, the alkaline type can last as much as four or five times longer. Heavy-duty zinc-carbon batteries are preferable to the regular type if alkaline are not available.

Choosing A Flashlight
You need a flashlight that is both powerful and reliable. Check to see that the flashlight you purchase has a plastic bulb holder. This helps protect the bulb in case the flashlight is jarred or dropped. Poorly designed flashlights don't have such a holder; this puts the bulb in direct contact with the battery. A sudden shock can then jam the battery into the bottom of the bulb and break it.

Six-Volt Lantern Flashlight This is the best all-around flashlight for emergency use. The lantern is rectangular in shape, with a carrying handle and a wide reflector which puts forth a broad beam of light. These rugged, waterproof lanterns, made from high-impact plastic, will

Lighting the Way 27

even float: you can throw one into a swimming pool and it'll keep right on shining. Although quite expensive versions of this lantern are sold, there's really no need to buy anything other than the basic model found in retail and discount stores. Since alkaline batteries are not commercially available in the six-volt size, the heavy-duty zinc-carbon battery is the best choice. A lantern equipped with this battery will give you eight hours or more of continuous light. When you buy the lantern, purchase an extra bulb at the same time. You can easily tape this bulb inside the lantern on the back of the large reflector, so you'll always have an extra.

"D" Cell Cylindrical Flashlight The minimum flashlight to have for emergency use is the traditional, cylinder-shaped, two-cell flashlight that uses "D" cells. More expensive models holding three, four, or five batteries are also sold. Alkaline batteries are the best type to use in this flashlight: they will keep it shining steadily for fifteen hours or more.

Handsize Flashlight Lightweight, compact flashlights that fit comfortably in the palm of your hand are sold at sporting goods stores. Although primarily designed for backpackers, they are a handy auxiliary light for around the house and are small enough to tuck conveniently into a purse or pocket. Even though the flashlight uses two small "AA" cell batteries, it puts out a surprisingly bright beam of light.

Getting The Most From Your Flashlight
Using a flashlight intermittently rather than constantly extends the life of the battery. In fact, weakened batteries can often be rejuvenated by giving them a rest.

Dirt and residue sometimes collect on the bat-

teries and terminals, and can interfere with a flashlight's operation. Simply wiping all the contacts with a cloth may restore a faltering flashlight.

Batteries function best at room temperature. High temperatures (such as those found in the trunk of a car) shorten the storage life of any battery. Cold won't *damage* a battery as heat will, but it dramatically decreases a battery's performance. Low temperatures slow the chemical reaction inside the battery, reducing the amount of power it will put out and decreasing its operating time. On a crisp winter evening, with the temperature at freezing, a battery's effectiveness may be cut in half. If the temperature falls to zero, its efficiency is seriously impaired, and by −20°F it is useless. Therefore, if you need to operate a flashlight in cold weather, protect it as much as possible from the cold. Put it under your arm, or warm the flashlight with your hands to extract as much life as possible from the batteries. A battery brought back to room temperature will function normally.

Storing Batteries If a battery is left long enough it eventually goes dead on its own as the chemical system inside slowly deteriorates. Keep your emergency flashlight equipped with fresh batteries so it can be used instantly. A cool, dry place preserves a battery the longest. An alkaline or heavy-duty zinc-carbon battery, under normal conditions, should stay fresh for two years.

Storing an extra emergency battery in the refrigerator is sometimes suggested. Although the colder refrigerator temperature does prolong the life of the battery somewhat, there is the disadvantage of dampness corroding the battery. Also, when the battery is taken out into a room, the warm temperature can cause moisture to

condense on it, which might interfere with its operation.

After purchasing a battery, check it in your flashlight to be sure it is fresh. Better to find out now that it doesn't work than in the middle of the night when you really need it. Tape the date of purchase on the battery for easy reference.

Rechargeable Batteries Rechargeable nickel cadmium batteries are sold in all common battery sizes. Though expensive initially, they can be recharged hundreds of times, but they are a poor choice for emergency use. They only hold a charge for a few months and may be dead when they are needed most. Also, they run out of power faster than alkaline or heavy-duty zinc-carbon batteries.

No battery should be recharged unless it is sold specifically for that purpose. Attempts to recharge a standard battery can damage the battery or even cause it to explode.

OTHER SOURCES OF EMERGENCY LIGHTING

Keep in mind that a flashlight only projects a direct beam of light. A lantern or a supply of candles can illuminate an entire room, making normal activities easier.

Lanterns A lantern that floods a room with light is a real advantage if a power outage lasts any length of time. Modern lanterns, powered by batteries, propane, or white gas, are as bright as an electric light. All these types of lanterns are sold at large retail stores and sporting goods outlets.

Battery-Powered Fluorescent Lantern A battery-powered fluorescent lantern is the best choice for short-term emergency lighting. It can be used in complete safety anywhere since it doesn't burn a volatile fuel. The lantern employs four six-volt lantern batteries to power two fluorescent bulbs, which easily illuminate a room with enough light to read by. The operation of the lantern is very simple: merely put in the batteries and flip a switch to one of three brightness settings. A set of heavy-duty batteries will last at least fifteen evenings at the brightest setting. Smaller models that use just two six-volt lantern batteries are also available. Although not as powerful, they still cast a good amount of light. Batteries from any of these lanterns are interchangeable with those from six-volt lantern flashlights.

Propane And White Gas Lanterns Even though these two types of lanterns put out more light than the battery-operated models, they are not really designed for indoor use. Care must be taken if they are operated inside because of the fire danger, especially with white gas. Also, any room in which these lanterns are used must be ventilated to prevent a build-up of toxic gases.

Candles Candles don't produce nearly as much light as a lantern, but they are inexpensive, always work, and store indefinitely. To reduce the fire danger, be sure you have candleholders, or use broad-base candles. A typical twelve-inch dinner candle has a burning time of at least eight hours. Candles which are larger in diameter burn much longer, with some providing as much as several days' burning time. Candles function best for background illumination. You can increase the amount of light from a candle by placing it in front of a mirror or other

reflective surface. Put some matches away with the candles so you'll always have a way to light them.

Plug-In Wall Lights Another convenient form of emergency lighting is a plug-in wall-socket light. Just a few inches in size, it plugs into a wall socket which keeps a power cell inside the unit constantly charged. If the power fails, this compact light instantly comes on, drawing on its power cell for electricity. Most models provide about ninety minutes of light. The unit can be unplugged and used as a small flashlight.

CHAPTER 4

Tuning in the Outside World

Reliable information in an emergency is the keystone on which all other actions should be based. A battery-operated transistor radio will furnish you with the means of receiving news as it happens. The link a radio provides can prove invaluable in facing a disaster. Knowing what to expect from the radio in an emergency, the best type of radio to have, and how to use it effectively are all crucial elements in disaster preparedness.

THE EMERGENCY BROADCAST SYSTEM

You've probably heard an announcer interrupt a radio program to conduct a test of the Emergency Broadcast System (EBS); it's hard to miss the piercing attention signal. Even though this test is frequently on the air, many people are unaware of the function of the EBS. The EBS is a voluntary system of commercial radio stations across the U.S. that was originally intended for use by the President in case of a national emergency. In recent years its function has expanded to provide information in case of local, state, or

regional disasters. The EBS has been used hundreds of times in the last few years to warn people of floods, hurricanes, tornadoes, and other natural and man-made disasters. Its use has undoubtedly saved many lives.

Over five hundred commercial AM and FM radio stations across the U.S. form the backbone of the EBS. Each of these stations operates as a control station for an Operational Area. Your community is in one of these areas. Every station in the system monitors another one nearby on a special receiver. In an emergency, word would be flashed from one control station in the system to the next by use of the attention signal which activates this receiver. The tone, along with a message to stand by for an emergency warning, is also used to alert listeners to stay tuned for important information. If a small area is involved, only a few stations will go on the air with emergency information. However, if a regional or national disaster occurs, word will also be sent via all radio and television networks and wire services.

Through a federal program, the control stations have been supplied with an emergency generator, two-way communication with the local Emergency Operating Center and, in some cases, a fallout shelter. Therefore, the control station in your area will have important communication links with emergency services and be able to broadcast even if the power goes out.

WEATHER RADIO

How would you like to have the most up-to-date weather information any time you want it? It's possible if there is a station in the Weather Radio Network near you. This network is run by the National Oceanic and Atmospheric Admin-

istration (NOAA), which operates over 350 weather stations throughout the U.S.

Each station broadcasts a tape recording of weather information in its geographic area. The tape is several minutes long and is constantly repeated. It is revised every two to three hours and sometimes more often if weather conditions warrant it. The broadcasts, which come directly from the National Weather Service, are geared to the local geographic area. Stations in coastal zones, for example, provide oceanic weather reports and information on marine conditions in addition to regular weather broadcasts.

If bad weather is in the offing, forecasters will interrupt the regular weather reports for special warning messages. Some radios are equipped with a device that automatically turns them on or sounds an alarm if a weather warning is being issued. These "warning alarm" radios are especially valuable for hospitals, schools, news media offices and public safety agencies.

At the back of this chapter is a list of the locations of the stations in the Weather Radio Network. They can usually be heard up to forty miles from the antenna site. All you need is a radio that picks up the weather band. The weather stations broadcast on one of three frequencies (162.40, 162.475, and 162.55 megahertz). Many radios, in addition to receiving regular stations, have this weather band as an added feature. Weather prediction is always a tricky business. A radio that receives the Weather Radio Network frequencies is the best way to stay abreast of changing weather conditions.

AN EMERGENCY RADIO

Unfortunately a new FM stereo tuner doesn't qualify as a good emergency radio. What's

needed is a battery-operated transistor radio capable of receiving the stations you need in an emergency. The best choice is a portable radio that picks up the standard AM and FM bands as well as the weather band. These are available at any large retail or discount store. If the price is too steep or you don't have a weather station in your area, then a standard AM/FM transistor radio is the best choice. If nothing else, at least have a cheap AM transistor radio on hand. It is also possible to buy a weather radio; small transistor models that only receive the weather band are sold in electronic stores and marine supply shops.

The emergency radio for your house should not be the one the teenagers take to the beach or out for disco dancing; it should always be in your home. Keep a fresh battery on hand for the radio. If possible, store the battery outside of the radio; thus if the battery ever leaks the radio won't be damaged. Rotating batteries for emergency use once a year will assure you of their freshness. Tape the date of purchase on the battery for easy reference. Batteries keep best in cool, dry conditions.

For emergency use, alkaline batteries are the best choice. Their highter initial cost is more than compensated for by the extra playing time and storage life you'll get. An alkaline battery will keep a radio playing roughly twice as long as the zinc carbon type. Size also affects how long a battery will power a radio. Nine-volt cells last the shortest amount of time. A small transistor radio using a nine-volt cell may average twenty hours of playing time with a zinc carbon battery and about twice that with the alkaline type. This compares with the much longer playing time of radios run on the penlite, "C" or "D" cell batteries. For example, a radio that operates on alkaline "C" cells can provide a week or more of around-the-clock listening.

USING A RADIO IN AN EMERGENCY

In an emergency, tune to a station in your local area which is broadcasting emergency information. In some circumstances, all radio communication may be knocked out. Simply keep trying until communication is restored. It is possible to receive many more stations on the AM band at night than during daylight hours because of changes in the atmosphere. Even a little transistor radio will bring in stations from a greater distance, sometimes several states away. Try this if stations in your area are off the air.

Car Radios

If a transistor radio is not available, a car radio can be used. Turn the key so the power in the car is turned on. It is not necessary to run the engine. A car radio uses very little power and can be played for hours with no fear of draining the car's battery. With the antenna extended to full length, a car radio may be able to receive a faint station slightly better than a transistor radio. However, don't depend on a car radio as a substitute for having a transistor radio; they are not nearly as convenient, and who knows if the car will be there when you need it?

CB Radios

Owners of CB radios may wish to monitor their sets during a disaster for information on local conditions. Channel 9, which is reserved for emergency communication and assistance to motorists, is monitored by law enforcement agencies. The usefulness of a CB radio may be limited in a major disaster because of overloading of the channels. Nevertheless, a CB radio may be able to provide an important communication link in an emergency.

Ham Radio

Ham radio often plays a pivotal role in an emergency. "Hams" are the unsung heros of many disasters, providing the first communication with a disaster area. Many ham radio operators have emergency generating capacity and are skilled in setting up "networks" to broadcast and receive emergency information from all over the world. An urgent message into or out of a disaster area can often be best sent via ham radio.

LOCATIONS OF WEATHER RADIO NETWORK STATIONS

Alabama
 Anniston
 Birmingham
 Dozier
 Florence
 Huntsville
 Louisville
 Mobile
 Montgomery
 Tuscaloosa
 Demopolis

Alaska
 Anchorage
 Cordova
 Fairbanks
 Homer
 Juneau
 Ketchikan
 Kodiak
 Nome
 Petersburg
 Seward
 Sitka
 Valdez
 Wrangell
 Yakutat

Arizona
 Flagstaff
 Phoenix
 Tuscon
 Yuma

Arkansas
 Ash Flat
 Fayetteville
 Fort Smith
 Gurdon
 Jonesboro
 Little Rock
 Star City
 Texarkana

California
 Bakersfield
 Barstow
 Coachella
 Crescent City/
 Brookings, OR
 Eureka
 Fresno
 Los Angeles
 Merced
 Monterey
 Point Arena
 Redding
 Sacramento
 San Diego
 San Francisco
 San Luis Obispo
 Santa Barbara

Colorado
 Alamosa
 Colorado Springs
 Denver
 Grand Junction
 Sterling

Connecticut
 Hartford
 Meriden
 New London

Delaware
 Lewes

District of Columbia
 Washington, D.C.

Florida
 Daytona Beach
 Fort Myers
 Gainesville
 Jacksonville
 Key West
 Melbourne
 Miami
 Orlando
 Panama City
 Pensacola
 Tallahassee
 Tampa
 West Palm Beach

Georgia
 Athens
 Atlanta
 Augusta
 Chatsworth
 Columbus
 Macon
 Pelham
 Savannah
 Waycross

Hawaii
 Hilo
 Honolulu
 Kokee
 Mt. Haleakala
 Waimanalo

Idaho
 Boise
 Lewiston
 Pocatello
 Twin Falls

Illinois
 Champaign
 Chicago
 Moline
 Marion
 Peoria
 Rockford
 Springfield

38 Just in Case

Indiana
- Evansville
- Fort Wayne
- Indianapolis
- Lafayette
- South Bend
- Terre Haute

Iowa
- Cedar Rapids
- Des Moines
- Debuque
- Fort Dodge
- Sioux City
- Waterloo

Kansas
- Chanute
- Colby
- Concordia
- Dodge City
- Ellsworth
- Topeka
- Witchita

Kentucky
- Ashland
- Bowling Green
- Covington
- Elizabethtown
- Hazard
- Lexington
- Louisville
- Mayfield
- Pikeville
- Somerset

Louisiana
- Alexandria
- Baton Rouge
- Buras
- Lafayette
- Lake Charles
- Monroe
- Morgan City
- New Orleans
- Shreveport

Maine
- Ellsworth
- Portland

Maryland
- Baltimore
- Hagerstown
- Point Lookout
- Salisbury

Massachusetts
- Boston
- Hyannis

Michigan
- Alpena
- Detroit
- Flint
- Grand Rapids
- Houghton
- Marquette
- Onondaga
- Sault Sainte Marie
- Traverse City

Minnesota
- Duluth
- International Falls
- Mankato
- Minneapolis
- Rochester
- Saint Cloud
- Thief River Falls
- Willmar

Mississippi
- Ackerman
- Booneville
- Bude
- Columbia
- Gulfport
- Inverness
- Jackson
- McHenry
- Meridian
- Oxford

Missouri
- Camdenton
- Columbia
- Hannibal
- Joplin/Carthage
- Kansas City
- St. Joseph
- St. Louis
- Springfield
- Sikeston

Montana
- Billings
- Butte
- Glasgow
- Great Falls
- Havre
- Helena
- Kalispell
- Miles City
- Missoula

Nebraska
- Bassett
- Grand Island
- Holdrege
- Lincoln
- Merriman
- Norfolk
- North Platte
- Omaha
- Scotts Bluff

Nevada
- Elko
- Ely
- Las Vegas
- Reno
- Winnemucca

New Hampshire
- Concord

New Jersey
- Atlantic City

New Mexico
- Albuquerque
- Clovis
- Farmington
- Hobbs
- Ruidoso
- Santa Fe

New York
- Albany
- Binghamton
- Buffalo
- Kingston
- New York City
- Rochester
- Syracuse

North Carolina
- Asheville
- Cape Hatteras
- Charlotte
- Fayetteville
- New Bern
- Raleigh/Durham
- Rocky Mount
- Wilmington
- Winston-Salem

North Dakota
- Bismarck
- Dickinson
- Fargo
- Jamestown
- Minot
- Petersburg
- Williston

Ohio
- Akron
- Caldwell
- Cleveland
- Columbus
- Dayton
- Lima
- Sandusky
- Toledo

Oklahoma
- Clinton
- Enid
- Lawton
- McAlester
- Oklahoma City
- Tulsa

Oregon
- Astoria
- Coos Bay
- Eugene
- Klamath Falls
- Medford
- Newport
- Pendleton
- Portland
- Roseburg
- Salem
- The Dalles

Pennsylvania
 Allentown
 Clearfield
 Erie
 Harrisburg
 Johnstown
 Philadelphia
 Pittsburg
 Wilkes-Barre
 Williamsport

Puerto Rico
 San Juan
 Maricao

Rhode Island
 Providence

South Carolina
 Beaufort
 Charleston
 Columbia
 Florence
 Greenville
 Myrtle Beach
 Sumter

South Dakota
 Aberdeen
 Huron
 Pierre
 Rapid City
 Sioux Falls

Tennessee
 Bristol
 Chattanooga
 Cookville
 Jackson
 Knoxville
 Memphis
 Nashville
 Shelbyville
 Waverly

Texas
 Abilene
 Amarillo
 Austin
 Beaumont
 Big Spring
 Brownsville
 Bryan
 Corpus Christi
 Dallas
 Del Rio
 El Paso
 Fort Worth
 Galveston
 Houston
 Laredo
 Lubbock
 Lufkin
 Midland
 Paris
 Pharr
 San Angelo
 San Antonio
 Sherman
 Tyler
 Victoria
 Waco
 Wichita Falls

Utah
 Cedar City
 Logan
 Roosevelt
 Salt Lake City

Vermont
 Brattleboro
 Burlington

Virginia
 Lynchburg
 Norfolk
 Richmond
 Roanoke

Washington
 Neah Bay
 Richland
 Seattle
 Spokane
 Yakima

West Virginia
 Charleston
 Clarksburg

Wisconsin
 Green Bay
 La Crosse
 Madison
 Menomonie
 Milwaukee
 Wausau

Wyoming
 Casper
 Cheyenne
 Lander
 Rawlins
 Rock Springs
 Sheridan

CHAPTER 5

Understanding Your Utilities

An earthquake, strong storm, flood, or evacuation may necessitate turning off your utilities. It's not necessary to have a degree in mechanical engineering to learn how to do this. Generally it's a simple affair, and a mere flick of a switch or turn of a valve does the trick. What's important is knowing where that switch or valve is and how to turn it. This chapter will show you, step by step, how to locate and operate all the utilities commonly found in a home, apartment, or building. Half an hour is all the time it should take to do the job. It'll be a lot easier to learn how to operate these shutoffs when there is time to practice, than to try and learn it in an emergency. With the exception of the gas shutoff, try to actually operate all valves and switches. Valves in particular may be somewhat stiff to operate after long periods of disuse. Once you have located and learned how to operate all your shutoffs, take the following steps:

1. Record this information on the cut-out page in the back of this chapter and post it where it can easily be referred to. This insures that anyone can find and operate the utilities in an emergency.

2. Clearly mark each shutoff. Do this by putting a dab of bright colored paint on the valve or by marking its location with a sign.
3. Keep any tools needed to operate a valve readily accessible.
4. Give every capable person in the household (including children) a quick lesson on the location of utility controls and how they work.

Organize the utilities at your workplace in the same way as at home. As many people as possible should know their location and how to operate them. Clearly mark the shutoffs, distribute a map of their location, and show employees how they work.

The location and method of operating utility shutoffs varies slightly in different buildings. The instructions in this chapter cover most situations. If for some reason you have doubts about what to do, call the utility company involved. If the problem can't be solved on the phone they can send someone out to help you at no charge.

WATER

There is always a master valve for shutting off a water supply. Shutting off the water prevents flooding from broken pipes. It also keeps contaminated water out of the building's plumbing.

All houses served by a water main have a hand-operated shutoff valve somewhere on the premises. In areas where winters are mild, this "gate valve" is often on an outside water pipe such as where a hose connects. Otherwise, it is located inside the house, often in the basement. *Always turn the valve clockwise to shut off the water.* Once the water is off, check faucets in the house

to be sure the whole system is shut down. Turn the valve counterclockwise and you have water again. Some plumbing systems, especially in larger houses, have shutoff valves for different sections of the building. Nevertheless, there still should be a master valve. Apartment houses vary; there may be one shutoff valve for each apartment or one valve may control several different units. The manager should know where the proper valve is.

If your home has a water meter it's quite probable that a shutoff valve is located there as well. The meter can be found in a variety of places. In warmer climates it is most often in a small cement "meter pit" embedded in the front lawn near the street. To get at the valve, insert a screwdriver through the slot in the top of the pit and lift off the cover. In areas that have a real winter, the meter will be found in the basement or utility room. The meter is a small metal box with a series of dials in it.

The shutoff valve is on the pipe going to the meter. It will usually be a metal valve stem roughly an inch long and one quarter inch thick. Use an eight- to ten-inch wrench to turn it. When the water is "on", the valve lies parallel with the pipe. Turning it 90 degrees, or a quarter turn, shuts the water off. Some valves may require a special tool similar to that used to turn on a sprinkler system.

ELECTRICITY

The electrical shutoff is probably the easiest of all the utility controls to find and operate. It's normally inside the house and requires no tools to turn it off. If a problem develops in an electrical system there is the immediate potential danger of fire or shock. Because of this, all elec-

trical systems are equipped with an automatic shutoff device called a circuit breaker or fuse. These are arranged in either a circuit breaker box or, in older buildings, a fuse box. This "service entry" not only protects the system but divides up the electricity into circuits that channel the power throughout the building. A circuit breaker or fuse acts as a protective link in an electrical system. It is intentionally built weaker than the rest of the circuit. Thus, if something goes amiss, the fuse will blow or the circuit breaker will trip rather than the wiring system itself heating up and possibly starting a fire. Even though such devices protect electrical systems it is still a good idea to know how to shut them off in case of arcing wires or an electrical fire. It is also a wise precautionary measure to turn off the power if you have flooding or need to evacuate under circumstances in which your home might be damaged.

While there is no real danger in handling either a circuit breaker or fuse, it does pay to be careful. Make sure you can see what you are doing and use a flashlight when necessary. Don't work on a wet floor; use a dry board to stand on.

Circuit breaker or fuse boxes are commonly located in a closet, kitchen, garage, or basement. Some houses will have more than one circuit breaker or fuse box. Most apartment units have their own individual circuit breaker or fuse box. You can tell whether you have circuit breakers or fuses by looking inside the box. A circuit breaker box contains a row or two of switches while a fuse box has glass fuses. Determine which type you have and then read the pertinent section that follows. If you have any questions on how your electrical system works, check with the local electric company.

Circuit Breaker Boxes

A circuit breaker is either a toggle or push-button switch. Most new buildings use circuit breakers because of their convenience. Unlike fuses that blow out and need replacing, circuit breakers simply flip off and can be reset. There will be a circuit breaker switch for each circuit in your home. A small apartment may only have two or three while a large house may have a dozen or more. *To turn off the power, flip all the circuit breakers to the "off" position.* Often, in addition to the regular circuit breakers, there will be one or two large switches that turn off all the circuits. They are there to make it quicker and easier to turn off the power. To turn the electricity back on, push each toggle switch to "on". Some circuit breakers need to be pushed to a "reset" position before being pushed to the "on" position. Large buildings may have more than one circuit breaker box.

A circuit breaker will not trip on its own; there

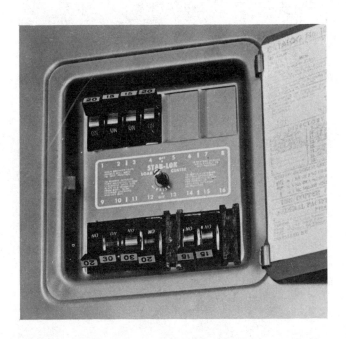

Understanding Your Utilities 45

is always a reason. Too many appliances plugged into a circuit, or shorted wires commonly cause a circuit breaker to trip. Always determine what the problem is before resetting the circuit breaker.

Fuse Boxes

Older buildings may still have fuse boxes. Instead of circuit breaker switches you'll see a row or two of glass plugs that screw in like light bulbs. Another type of fuse is a cylindrical "cartridge" that clips into a pull-out section of the fuse box panel. The main shutoff switch for a fuse box varies. There may be a lever on the outside of the box (usually on the left side) that will cut all power. When the lever is up the

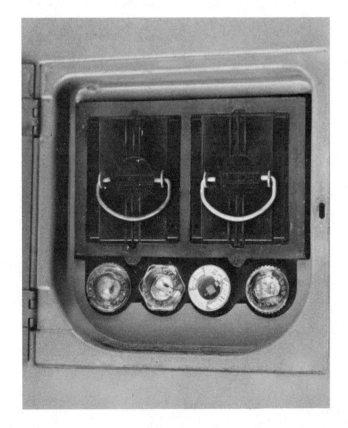

power is on; the down position will shut the power off. Other types may have a removable section that "unplugs" when pulled out of the main panel by its handle. It is often marked "Main". Again, remember that there may be more than one fuse box in the building. To make sure all the power is off, check all light switches and outlets.

When a fuse blows it often causes the face of the fuse to cloud up or turn black. The reason it has blown should be determined before replacing it with a new fuse of the same rating and type. Never put a penny behind a blown fuse to make it work and always turn off the power before changing a fuse.

NATURAL GAS

Many areas of the country use natural gas for heating, cooking, and operating certain appliances. It is clean, efficient and trouble-free under normal circumstances. Unfortunately, if gas escapes to the atmosphere there is an immediate danger of fire or explosion. While it's important to locate and understand how to turn off the gas, it is the one utility where it's best not to actually test the shutoff valve. With the exception of some very new appliances, all gas-operated equipment will have at least one, and sometimes several, pilot lights. Turning off the gas will shut down all these pilots. It is all too easy to miss relighting a pilot which could cause a gas leak with potentially serious results. Appliances that commonly use gas include ranges, refrigerators, water heaters, heating systems, and clothes dryers. Unless you're positive where each pilot is and how to light it, don't turn the gas off except in an emergency.

When To Turn Off Your Gas

Always turn off the shutoff valve if you can smell gas. You may also wish to turn off the gas as a precautionary measure if forced to evacuate in the face of a strong storm or other situation where there may be serious damage to your home. Once the gas has been turned off, let the gas company turn it back on and relight the pilots unless you're absolutely certain you know how to do it yourself. If there is any chance of a gas leak, be sure to call the gas company to check the system.

An odor is added to natural gas so it can easily be detected. If you smell gas, get everyone out of the building as fast as possible. Open windows and doors to air out the building and to prevent a buildup of gas. Turn off the main shutoff valve. Then have the gas company out to locate the source of the leak. Don't use a flame or electrical appliances, or operate light switches either on or off, if there is any suspicion of gas in the air. If a gas main breaks elsewhere, under a street for example, get away from the area immediately and notify the fire department and the gas company.

The Gas Shutoff

The shutoff valve is located at the gas meter, which is sometimes found in the basement or in a utility room. In warmer parts of the country the meter is usually outside the building, along a side or back wall, about a foot above the ground. Regardless of its location, the meter is a metal box, roughly a foot square, with a set of dials on the front. You will see a pipe coming out of the ground or basement wall that connects into the meter; the meter itself; and another pipe leading to the gas appliances in the building. The shutoff valve you want is on the pipe coming out of

the ground or wall and leading to the meter; this is usually on the left-hand side. The valve stem is about ⅜ inch thick and about an inch long. When the valve is parallel with the pipe it is in the "on" position. *To shut off the gas, turn the valve 90 degrees or one quarter turn in either direction with a wrench.* To turn the gas back on, turn the valve in either direction so it again lines up parallel with the pipe.

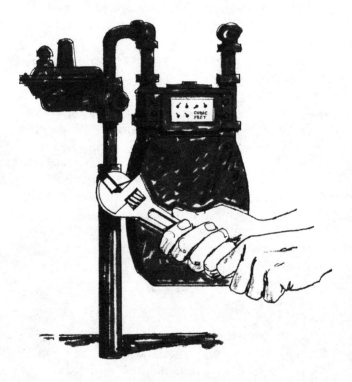

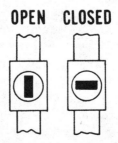

In an apartment building there may be a row of meters, one for each of the different units. Someone should be responsible for knowing how to turn all these meters off. Gas meters are pretty standard throughout the country. If for some reason yours seems different or you're not positive where the shutoff valve is, call your local gas company and they will be able to explain it to you. Find a place close to the meter to keep a large ten- to twelve-inch wrench which will fit the valve stem. A good idea is to have a wrench specifically for turning off the gas.

LIQUEFIED PETROLEUM

Trailers, mobile homes, and buildings in rural areas often use liquefied petroleum products such as propane or butane to operate certain appliances. The liquefied petroleum will be stored in a tank outside the building. The shutoff valve can be found at the tank on the gas line leading into the house. It should be a hand-operated valve requiring no tool. If you're not sure where it is or how it operates call the service company and get the information.

OIL-BURNING FURNACES

In large sections of the U.S. many buildings use oil-burning furnaces in the winter. To shut down this utility, you must do two things: *turn off any electrical power going to the furnace, and shut off the oil supply.* There are several types of furnaces that use heating oil, but the basics are all the same. The electrical switch and oil valve should be easy to find and operate.

Locate and turn off the master power switch for the furnace; it should be located somewhere

near the unit. Next, close the valve on the oil supply line. It is somewhere between the oil storage tank and the furnace and is often a hand-operated valve. If your furnace does not use electrical power, all you need to do is shut off the oil.

These are general directions and apply to most furnaces. However yours works, it should be straightforward and simple. Operational instructions should be written somewhere on the furnace. If you have any questions call and ask a furnace maintenance person.

A FEW FINAL WORDS ON UTILITIES

You now have all the information needed to find and operate the utility shutoffs in your home. The final step is to take a few minutes and locate, operate and label the shutoffs. It will be time well spent. Record the information on one of the following cutout pages and post it in a convenient location. The other page is for use at work or anywhere else this information needs recording. You can then be assured that if an emergency arises requiring one or more of the utilities to be shut off, you'll know what to do.

UTILITY SHUTOFFS

WATER SHUTOFF

Location _____

How to do it _____

ELECTRICAL SHUTOFF

Location _____

How to do it _____

GAS SHUTOFF

Location _____

How to do it _____

UTILITY SHUTOFFS

WATER SHUTOFF

Location _____

How to do it _____

ELECTRICAL SHUTOFF

Location _____

How to do it _____

GAS SHUTOFF

Location _____

How to do it _____

CHAPTER 6

A Complete Guide to Fire Extinguishers and Smoke Detectors

Would you like to buy a great fire insurance policy? Only a few dollars a year guarantees protection. There are no forms to fill out and no agents will call you. To take advantage of this bargain all you need to do is read this chapter and purchase two inexpensive items—a fire extinguisher and a smoke detector. They can be your first line of defense against a fire. Early warning plus an effective way of putting out a blaze can turn potential trouble into a minor inconvenience. In a disaster where help may not be rapidly forthcoming a fire extinguisher and a smoke detector can be invaluable. So don't delay. The following sections will provide you with all the information you need to purchase this economical insurance policy.

FIRE EXTINGUISHERS

WHY HAVE A FIRE EXTINGUISHER?

It doesn't take a disaster to make a fire extinguisher a very handy tool. The first few minutes

of any fire are critical. Knocking it down quickly with the proper fire extinguisher can mean the difference between simply recharging the extinguisher and getting to know the fire insurance adjuster better than you'd care to.

A true disaster situation adds a whole new dimension. If a fire does start it may be impossible to get a call through to the fire department. Even if the call is received they may not be able to reach you. Having the proper fire extinguishers and the knowledge of how to use them is a good hedge against a small-scale disaster of your own at home or in your car.

Fire extinguishers come in all shapes, sizes, and colors. There is no standard way they all work. This chapter will cover all the different types of fire extinguishers you're likely to come across, how to use them, and how to choose which is best for your home, car, school, or place of work. But before fire extinguishers can be discussed it's necessary to understand something about fires.

TYPES OF FIRES

Fires aren't all the same. What works to put out one may actually make another worse. To simplify matters and distinguish between different types of fires, a standardized classification system has been set up. Fires fall into three general classes, depending on the type of fuel they burn.

Class A This is the most common type of blaze. Class A fires involve ordinary combustibles such as paper, wood, a mattress, clothing and curtains. This is the only type of fire that can be safely put out with water. Class A fires can also be smothered.

Class B This type of fire is fueled by burning flammable liquids. They are either chemicals or petroleum products. Fires involving gasoline, oils, paints and kitchen grease are all examples. A Class B fire must be smothered. *Water should never be used* in fighting this type of fire; it is not only ineffective but may splatter and spread the fire. It can even cause an explosion.

Class C These are electrical fires. Motor and appliance fires fall into this category. Smothering with a non-conducting fire extinguishing agent such as baking soda or sand will put out this type of blaze. *Water must never be used* because of the danger of electrocution.

HOW TO READ A FIRE EXTINGUISHER LABEL

The numbers and letters on any fire extinguisher will tell you two things—how powerful it is, and what type or types of fire it can be used against. The letters correspond to the different types of fires. Fire extinguishers nearly always fall into one of the three categories listed below.

A Extinguisher This kind of extinguisher contains water and is effective against Class A (wood, paper, etc.) fires only. It should never be used on a Class B or C fire.

B:C Extinguisher This type will smother a Class B or C (oil or electrical) fire. While not very effective on a Class A fire, it can be used without fear of making things worse.

A:B:C Extinguisher This extinguisher will put out any type of blaze.

Preceding the letter or letters on the label will

be a number. This gives the strength of the extinguisher as set by the government. How the numbers are arrived at is somewhat technical. Basically, the higher the number the greater the extinguishing power. A typical rating might read 5B:C. That means the extinguisher works on both a Class B or C (oil or electrical) fire and has a strength of 5. All extinguishers rated 5B:C will have the same power. A 10B:C extinguisher has twice the power of a 5B:C. The strength rating for Class A extinguishers works the same way except the numbers are lower. A 2A extinguisher has twice the capacity of a 1A.

HOW TO CHOOSE A FIRE EXTINGUISHER FOR YOUR HOME AND CAR

The best kind of extinguisher to buy is the dry chemical type. This is normally the only kind sold for private use. Fire extinguishers are available in all large department stores and most large hardware stores. There are also retail outlets that sell nothing but fire extinguishers. Although they sell primarily to commercial customers you may wish to consult with one of them if you have special requirements.

In buying a fire extinguisher check to see that it is approved by Underwriters Laboratories. It should say "UL Approved" somewhere on the label. This means it meets government standards. Since these standards apply to all extinguishers, the brand name is not very important. Large stores sometimes carry their own brands. Shop around; fire extinguishers are often on sale.

4B:C or 5B:C These are sometimes known as "beer can" extinguishers because of their size.

They are the smallest and least powerful sold. They range from six inches to less than a foot in length.

10B:C These are double the power of the 5B:C and excellent for auto use. They are about a foot long.

1A:10B:C This is the smallest multipurpose extinguisher sold: it is about seventeen inches long.

2A:10B:C and 2A:40B:C These are both excellent multipurpose extinguishers for home use. They are both about nineteen inches long.

4A:60B:C and 10A:80B:C These two extinguishers may have to be special-ordered through a catalog. They are larger than usually needed for a house. Both of these extinguishers are a little less than two feet in length.

Extinguishers For Your Home

Ideally your home should have more than one fire extinguisher. An extinguisher should be close to any area where there is a possibility of a fire. There should be one in or near the kitchen, another for living and bedroom areas and another for the garage. Two-story houses should have one on each floor. Any other separate area such as a basement or outbuilding should have one. It's better to have several smaller extinguishers well distributed throughout the house than a large one that is hard to get at quickly.

A good arrangement for a one-story house is a 10B:C extinguisher in the kitchen, another in the garage and a 1A:10B:C for the rest of the house. If you can only buy one extinguisher get an A:B:C type that works on any fire. A 2A:40B:C is a good multipurpose extinguisher. People with

special fire hazards may wish to purchase one of the larger models. Remember that the bigger extinguishers are heavier and harder to handle.

Having an extinguisher within easy reach is only half the battle. You need to make sure everyone in the house knows where it is and how to use it. There should be simple but explicit instructions on the side of the extinguisher on how to use it. Children old enough to handle the extinguisher should learn too.

Extinguishers For Your Car

A 10B:C extinguisher is the best type for a car. It has twice the power of a 5B:C and is roughly the same size and just a little more expensive. Most 10B:C extinguishers come with bracket attachments to securely fasten it out of sight under the dashboard. It can also be stowed under a front seat. Put the extinguisher somewhere in the passenger compartment, not in the trunk. Multi-purpose extinguishers such as a 1A:10B:C are not only unnecessary for car fires but too bulky to fit conveniently in many cars.

It is a law in most states that recreational vehicles, trailers and boats be equipped with one or more fire extinguishers of specific sizes.

HOW TO USE A FIRE EXTINGUISHER EFFECTIVELY

Now that you have a fire extinguisher, all that's left is to learn how to use it. First a word of warning. The most important thing to do in any fire is to save lives. Fires can move faster than it's comfortable to think about. Get everyone out of the house or building and make sure the fire department is called. Now take the fire extinguisher and pull the pin on the handle. Aim for the base of the fire or smoke. Using short bursts,

sweep the part of the fire closest to you. Be careful that the fire doesn't flare up or explode back towards you. Most fire extinguishers have about ten seconds of spraying time. The first burst, powered by the most pressure, will be the strongest. The spray should carry at least ten feet.

It's important to realize the limitations of fire extinguishers. They work best against small fires. Don't try to put out a fire that is obviously out of hand or too big to handle. Always keep a quick exit constantly ready so the fire doesn't block you off. Stay well back from the flames. Crouch low and take short careful breaths; it's easy to be overcome by smoke or gas from the fire. Try not to breathe the powder from the fire extinguisher. If you are outside, stay upwind of the fire. Even if you've managed to put the fire out, make sure the fire department comes to have a look. Fires have a nasty habit of starting up again.

Car Fires

A car fire can happen with incredible speed. All it takes is a fuel hose breaking loose, spilling gasoline on the hot engine, and suddenly smoke and fire are pouring from beneath the hood. In minutes a new car can turn into a candidate for the junkyard.

Again the first step is to save lives. Pull to the side of the road and turn off the ignition. Taking the extinguisher with you, get everyone out and away from the car. Make sure the fire department is called either by phone or CB radio. Be extremely careful fighting a car fire. A gasoline fire can easily flare up or explode. Certain types of car safety bumpers may also explode from the heat. Stay well back from the car at all times. Don't lift the hood when the engine is burning. Instead, use the extinguisher to spray through

the front grill and across the top of the hood. This can be quite effective in knocking the fire back and buying time until the fire department arrives.

REPLACING OR RECHARGING A FIRE EXTINGUISHER

All fire extinguishers will have a gauge on top to show if they are ready to operate. When buying a fire extinguisher make sure the gauge shows it to be fully charged. Check occasionally to be sure it is still charged to the proper level. After many years the powder inside tends to get packed down. Even though the gauge indicates that they are charged, very old extinguishers should be replaced.

If you have used your extinguisher or the gauge indicates it is low on pressure, the unit should be replaced or recharged. A fire extinguisher can be recharged at a store dealing exclusively in fire prevention equipment.

FIRE EXTINGUISHERS AT WORK

Supermarkets, gas stations, offices, schools—almost any building in fact is equipped with at least one fire extinguisher. Many will not be the dry chemical type you'll have at home or in your car. For a variety of reasons other kinds are sometimes used. The three most common types are:

Multipurpose Dry Chemical
This is the same familiar extinguisher that you have in your home. It will probably be a more powerful size, however. This is the best type of extinguisher for all-around general use.

Soda-Acid
These are large extinguishers, often silver or brass in color, with a circular metal stand at the top. They have a number of disadvantages. They only work on a Class A (wood, paper, etc.) fire. They must be turned upside down to work, something many people aren't aware of. Their heavy weight makes it difficult for many people to lift them off the wall and haul them to the fire. Because of these problems, the manufacture of soda-acid extinguishers has been discontinued in the U.S. While many are still in use, they are gradually being phased out.

Carbon Dioxide (CO_2)
This is basically a tank filled with carbon dioxide gas. It works best on oil and chemical fires or in confined spaces. The CO_2 discharged through the nozzle is extremely cold. Be sure to hold the nozzle at the insulated handgrip to keep the freezing CO_2 from "burning" your hand. Don't be startled by the loud whooshing sound the gas makes.

Next time you have a chance, take a close look at the extinguisher hanging on the wall where you work. Is it a fire extinguisher that will operate easily and effectively against the most likely type of fire you might have? Or is it, like too many extinguishers, a mere ornament offering a false sense of security? Would you know how to operate it in an emergency? One of the best ways to find out is to have a fire extinguisher demonstration.

FIRE EXTINGUISHER DEMONSTRATION

Having the right kind of fire extinguisher ready to use is one thing. Getting to practice with it on

a real fire is quite another. No fire department wants people setting their own "practice" fires. There is a way, however, to see what a fire extinguisher will do before an emergency arises. All it takes is a call to the local fire department. Most fire departments will be happy to do a fire extinguisher demonstration for a group of people, a business staff, or a school.

The advantage of having the extinguisher demonstration at work is that you'll become familiar with the extinguisher you have there. All business or government buildings are required to recharge their extinguishers periodically. If you use the extinguishers due to be recharged, the demonstration costs nothing but the time.

The fire department may set a small, contained fire somewhere outside, for example in a parking lot, open field, or playground. You'll then get to see how big a fire an extinguisher can tackle and perhaps get to try putting it out yourself.

SMOKE DETECTORS

Sensing a fire quickly can save lives and property. At night this may be difficult. Smoke and gas from a fire can dull the senses, slow down thinking, and decrease reaction time. Worse still, it can overcome sleeping victims before they are able to wake up. You may possess the world's most sensitive nose and be an extremely light sleeper—but why gamble? Sleep as soundly as you like and let a smoke detector stay alert for fires.

Inexpensive, easy-to-install smoke detectors that sound an instant warning in case of a fire are now available. A loud piercing horn guaranteed to arouse the soundest of sleepers signals

the early stages of a fire. Time is gained and lives are saved. Every home should have one. In many states, smoke detectors are now required in all new construction. Smoke detectors are doubly important during a disaster. In a time when fire equipment may not be able to reach you quickly, early warning of a fire is crucial. The following section will provide you with all the information to equip your home with a smoke detector.

BUYING A SMOKE DETECTOR

Any large retail or hardware store should have smoke detectors. Buy your smoke detector from a reputable store. Never purchase one from a door-to-door salesman or at a swap meet. Make sure it is approved by Underwriters Laboratories. It should say "UL Approved" on the box. Some states require further approval, for example by the state fire marshal. Only two different types of detectors need be considered for your home. The most widely used is the ionization chamber detector. The other type is the photoelectric detector.

Ionization Chamber Smoke Detectors

Despite the imposing name, these devices are simple, easy to use, and best of all, inexpensive. They are circular in shape, measuring about six inches in diameter and two inches in thickness. One of these will nestle inconspicuously against the ceiling in any room. They are sold in a variety of colors to match a room's decor.

The detector constantly sniffs the air in the room, searching for the first particles of combustion from a fire. A small amount of radioactive material ionizes the air within the sensing chamber. If any smoke enters the sensing cham-

ber, it breaks a small electric current and triggers the alarm. A piercing 85-decibel horn blasts out an alert. It will keep sounding for several minutes or until the smoke diminishes to a safe level.

Although the use of ionization chamber detectors is approved by the government, some consumer groups have expressed concern about the presence of a radioactive substance in these units. In particular, be sure to dispose of the detector properly by sending it back to the manufacturer as is recommended.

There are two kinds of ionization chamber smoke detectors sold:

DC Powered This smoke detector is battery-operated. It is the best smoke detector to buy for most homes. Because it is powered by a long-life battery, you can always count on it to work. Most units have a test button that allows you to check the detector periodically. Pushing the button sounds the alarm and indicates that all circuits are working. When the battery gets low it will cause the detector to give a short beep once a minute for seven days to let you know it needs replacing. The battery will last about one year.

AC Powered These models use the electrical current in your house for power. They have a cord that either plugs into a nearby wall socket or is connected into the house wiring. *An AC powered detector is not recommended.* This detector will work only as long as the power to your house is functioning. If the power should fail for any reason you will be left without protection. A simple fire can cut the power to your house by burning or shorting out the wiring system. In a disaster situation the power may be cut off for hours at a time, again leaving you unprotected just when protection is needed the most.

Photoelectric Smoke Detectors

Battery-powered photoelectric detectors work by shining a light across the sensing chamber. If smoke enters the chamber it blocks some of the light and triggers the alarm. Photoelectric detectors are about the same size as the ionization kind. They differ from ionization detectors by being a little less sensitive. This may be good in certain situations. In an apartment or small mobile home, kitchen fumes that will accidentally set off an ionization detector will not disturb the photoelectric type. In fact, some say that an ionization detector will go off if a bottle of horseradish is held under it! While this is an exaggeration, ionization detectors may be too finely tuned for some homes.

WHERE TO PUT SMOKE DETECTORS IN YOUR HOUSE

Always install a smoke detector on the ceiling or as near to it as possible, since smoke rises and collects there. The main area to protect is your bedroom. A detector should be located between any sleeping areas and the rest of the house. Thus smoke from a fire in any other part of the house must pass across the detector before entering the bedroom. One should also be placed at the head of any interior stairway. You may wish to install detectors in other sections of the house such as a basement or workroom. Special remote sensing units are available for this kind of situation; they will set off an alarm in the house if there is a fire in an outbuilding.

REPLACING A SMOKE DETECTOR

If you have a fire, heavy smoke will clog the circuits of a smoke detector and it should be

replaced. Some older smoke detectors that are dirty may start "falsing" or sounding an alarm when there is really no fire. They also should be replaced. When discarding the ionization type, it is recommended that you send it back to the manufacturer so the tiny bit of radioactive substance can be properly disposed of.

CHAPTER 7

Storing Food and Water

Until a generation or two ago it was common practice for people to stockpile a reserve of food in their pantries or cellars as insurance against lean times. Modern food processing and the corner supermarket have changed all this, and "putting food by" has gone the way of the horse and buggy. Some things remain unchanged, however. Even today a hurricane, earthquake, winter storm, blackout, or other emergency can disrupt your normal supply of food and water for several days. An emergency stockpile of these necessities allows you to be self-sufficient if a disaster isolates you in your home. Generally, a supply of four or five days' worth of food and water will enable you to outlast most of the disasters covered in this book. However, you may wish to stock up for a longer period of time if you judge it necessary.

STORING FOOD FOR AN EMERGENCY

Try to select foods that:

1. require little or no cooking in case utilities are disrupted.

2. have a long storage life.
3. need little or no water for preparation if the water service is interrupted.

Also try to select foods your family eats regularly, as it is best to serve familiar dishes in a stressful situation.

For short-term emergencies, there are two main types of foods to choose from: canned and packaged foods, or freeze-dried or dehydrated foods.

Canned And Packaged Foods

Even though canned goods are heavy and bulky, they offer a number of advantages. They don't require cooking or water for preparation. They can be integrated into your regular food supply. And with good storage conditions, they will remain fresh for about two years.

If you put the date of purchase on the cans and packages, you'll know when to rotate them into your normal food supply. Choose package sizes or cans that contain portions small enough for one meal, so food won't be wasted.

What To Store All these foods will keep from one to two years with only a slight loss in their nutritive value, texture, color or flavor:

1. Canned stew, spaghetti, corned beef hash, soup, beans, tuna, sardines, meats, fruits, and vegetables.
2. Drinks such as coffee, tea, bouillon, sodas, and canned juices.
3. Crackers, and spreads for crackers such as peanut butter, canned meat, and cheese.
4. Salt, pepper, sugar and other spices.

5. Hard candies, raisins, canned nuts and instant puddings.
6. Dried and/or evaporated milk.
7. Specially prepared foods for anyone in your family who requires them.

Freeze-Dried Or Dehydrated Foods

If you don't have the space to store an emergency supply of canned and packaged goods, freeze-dried or dehydrated foods offer a good, but more expensive, alternative. These low-moisture foods are lightweight and compact, and will stay fresh for about two years. Freeze-dried and dehydrated foods are primarily used for backpacking and are sold in camping and sporting goods outlets and some health food stores. They are prepared in one-meal foil packets with selections ranging from beef stew to lasagne. Their greatest disadvantage is that they need to be reconstituted with water. Many of the selections require cooking as well.

LONG-TERM FOOD STORAGE

More elaborate food storage methods are available for those who wish to store large quantities of food for long periods of time. There are two general types of food to use for long-term storage programs: special "survival foods" and specially packed dehydrated foods.

Survival Foods The four basic survival foods are wheat, powdered milk, honey, and salt. Legumes, sugar and grains other than wheat are also sometimes considered survival foods. With the exception of powdered milk, all these foods will store at least ten years. Nutritionists disagree on how long powdered milk will store,

with estimates ranging from two to ten years. These basic foods provide a diet that can sustain a person for several months or longer.

Hard winter wheat is the cornerstone of any survival food storage program. In addition to being a versatile, nutritious food, wheat will keep for at least twenty years. In fact, if properly sealed in an airtight container and stored in a cool (40 to 60° F), dry location, wheat will keep virtually indefinitely. Through a simple process it even can be sprouted to provide extra vitamins.

One of the best sources of information on these survival foods is the Mormon Church (Church of Jesus Christ of Latter-day Saints). As a matter of policy, the Mormon Church encourages its members to stockpile a year's supply of food in their homes as insurance against hard times. A number of Mormons have written books or pamphlets on long-term food storage. One of the best books is *Passport to Survival* by Esther Dickey (Random House, 1969; hardcover, 180 pages). Dickey bases her storage program on the four basic survival foods. Her book tells how to buy and store these foods successfully and contains over one hundred menus and recipes.

In some areas, the Mormons have stores where you can buy these foods in bulk, along with other items such as wheat grinders and storage containers. Someone at a local Mormon Church may be able to tell you where such a store is located and also give you other sources of information on long-term food storage.

Dehydrated Foods Another way to set up a long-term food storage program is to buy a kit of specially packed dehydrated foods. The kits contain a wide selection of foods, ranging from fruits and vegetables to meat substitutes and desserts. The food is packed in heavy-duty tins

and sealed with an inert gas inside. Dehydrated food packed in this manner will store well for ten years or more if kept in a cool, dry location. The kits are packaged to feed a specific number of people for a certain length of time. A typical kit is designed to feed one person for an entire year. The kits are relatively compact and a year's supply will fit in a hall closet. Look under "dehydrated food" in the yellow pages of your telephone book for the dealers in your area. Prices on the kits vary considerably, so it's worth checking with several outlets.

Other Items To Store

In addition to food, a few other basic items should be stored. These will be useful if the utilities are disrupted:

1. Paper plates and cups.
2. Plastic eating utensils.
3. Manual can and bottle opener.

WHERE TO STORE YOUR FOOD

How long your food lasts depends to a great extent on how it is stored. The ideal location is a cool, dry, dark place. The best temperature for storage is 40°F to 60°F. High temperatures contribute to a rapid deterioration of most types of food. On the other hand, canned or bottled goods containing liquids may be damaged if they freeze. Use a shelf in a pantry, basement, or other convenient location to store your food. Keep the food away from petroleum products such as paint that might impart an odor, and protect it from rodents and insects. Items that are in boxes or paper cartons keep longer and are safer if heavily wrapped or stored in metal containers.

HOW TO USE EMERGENCY FOOD

Use any perishable food in your refrigerator or freezer before digging into your emergency kit. Be sure any food that has been stored a long time is safe to eat. Discard any cans that bulge at the end or are leaking. Food that smells bad or has mold on it should be thrown out.

FURTHER INFORMATION ON FOOD STORAGE

For those desiring more information on storing food for short-term emergencies, the U.S. Department of Agriculture offers a fifteen-page booklet. It includes details on food storage procedures and sample menus. The cost is eighty cents. Write to:
 "Family Food Stockpile for Survival"
 Home and Garden Bulletin Number 77
 Superintendent of Documents
 U.S. Government Printing Office
 Washington, D.C. 20402

STORING WATER FOR AN EMERGENCY

Many different types of emergencies can disrupt your water service, forcing you to rely on whatever you have available in your home. You may wish to store a few gallons of fresh water to ensure a safe supply. Generally, two gallons per person should last several days. This supply can be used in conjunction with other sources of water in your home, such as the hot water heater. You may be able to collect extra water in containers before the actual emergency begins. Refer to Chapter 14 for complete information on finding and purifying water.

STORING WATER

The most convenient way to store water is in plastic jugs. One-gallon plastic containers of distilled water are sold in most supermarkets. Or, you can fill empty plastic bleach or milk containers with water from the tap once they have been thoroughly rinsed out. Larger five-gallon plastic containers, also handy for storage, are sold in large retail or discount stores. After a number of months, water kept in plastic containers develops a rather unsavory plastic taste, making it necessary to empty and refill the jugs occasionally. No matter how you store water, it always presents the problem of being heavy and taking up a fair amount of space. Store your containers in a location where the temperature won't dip below freezing. If the stored water appears cloudy or tastes bad, don't drink it until it is purified.

WATER PURIFICATION

Besides storing water, be sure you have a means of water purification. Either liquid chlorine bleach or water purification tablets will do the job. (See Chapter 14 for details.)

CHAPTER 8

Hightailing It: How to Evacuate

Every year tens of thousands of Americans are forced to leave their homes temporarily. In the event of an evacuation you'll need to know what you should do, what to take with you, what to expect at a public shelter, and how to travel in an emergency. Armed with this knowledge, you'll know the right actions to take if you ever have to evacuate.

PLANNING AHEAD FOR AN EVACUATION

Most people will benefit by taking a moment and thinking out what would need to be done if an evacuation ever became necessary. By formulating and discussing plans with everyone in your home now, you can avoid confusion and make the whole process of evacuating easier. This especially applies to people living in high-risk areas such as hurricane-prone coastlines or low-lying floodplains.

Your family should have an evacuation plan tailored to your particular location. Make sure everyone is clear as to where to go, how to get there, and what would be done if various family

members are at school or work. List items of special importance or value that you would want to take with you so that an important contract or a special painting doesn't float away in the flood waters. Plan what arrangements would be made for any pets or livestock you own, as no one with a carload of animals will be very welcome at a public shelter. Take a few snapshots of the interior of your home for insurance purposes. These pictures, along with receipts or serial numbers of expensive items, should be kept in a safe deposit box.

WHEN TO EVACUATE

The fierce winds of a hurricane roaring toward a beachfront area make the need to evacuate quite obvious. In other situations, knowing when or if to hightail it may be agonizingly difficult. Is it worth taking a risk, for example, in trying to save a home in the face of a brush fire? Unless there is an official order to evacuate there will be no easy answer to this dilemma. Most people are reluctant to leave their homes. As a result, all too many people wait until the last possible moment before heading for a place of greater safety. Don't get caught in the "stay with my home at any cost" syndrome. Property is replaceable; lives aren't. When deciding if it's necessary to leave, remember that the most important consideration is your safety and the safety of those around you. Time may be a factor. Roads can become clogged with traffic or impassable due to weather conditions. Realistically assess the situation and get out while it's still possible.

In many disasters, government officials will issue evacuation orders for endangered areas. If such an order is given, obey it; officials won't

require an evacuation unless it is truly necessary. But if an evacuation *hasn't* been officially ordered, this doesn't mean you shouldn't get out if it seems warranted; use your own judgment. Government officials are far from infallible, especially in new or unusual circumstances. The indecision about evacuating the towns near the Three Mile Island nuclear power plant was an example of confusion among public leaders as to what should be done.

If the possibility exists that you might have to head for an area of greater safety, then it's time to begin evacuation preparations. Events may develop faster than expected. Load the car with items you'll need. Make sure you have enough gasoline, as gas pumps operate on electric motors and will not work if the power goes out. Begin thinking about where to go and how to get there.

WHERE TO GO IN AN EVACUATION

The best place to go will depend on the scope of the emergency. A swollen creek that threatens a few homes along its banks may simply force residents to check into a hotel for the night. On the other hand, a major flood or storm involving thousands of people may mean that a space on the floor of a school gymnasium will be the best refuge that you can find. The most comfortable and least expensive shelter would be the home of a friend or relative living out of the danger zone. If this is not available, a hotel or motel room is the next best bet. People needing lodging because of a disaster can always get help through the Red Cross. Even if only one family is affected, the Red Cross will help find them a place to stay, and will help with the expense if

necessary. The least comfortable alternative, but perhaps the only one possible in large-scale emergencies, is a mass shelter. Locations of these facilities will be announced on the radio.

What To Expect At A Mass Shelter

A night or two at a mass shelter will definitely not compare with a stay at the Hilton. A public shelter is not selected for its comfort or cuisine, but rather for its capacity to house many people at a time. High schools, large meeting halls, or other buildings with cooking and sanitation facilities nearby will be used. The organization of the shelter and the accommodations available will depend largely on what steps have been taken before an emergency occurs. Some mass shelters are well planned, with arrangements for providing food, water, blankets, cots, and medicines to the occupants. A shelter manager will be in charge of the operation and some type of registration or check-in procedure will exist. Unfortunately, some areas are not well prepared. Where this is the case, people will have to rely on what they bring to the site and what can be transported in. So it's wise to come to a mass shelter well prepared to care for your own needs. It will make a stay at even the most well-organized shelter more comfortable.

WHAT TO TAKE WITH YOU IN AN EVACUATION

No matter where you're headed, take as many necessities as possible with you. What you can't use yourself can be shared or traded with others. Use a bag, box. or suitcase to help keep your belongings organized. Here are the twelve most important items to take with you:

1. **Water**—Carry it in thermoses, picnic jugs, or plastic containers, not in breakable glass bottles.

2. **Food**—Bring foods such as canned goods that are easy to transport, won't spoil, and don't require cooking.

3. **Bedding**—Bring sleeping bags and air mattresses if you have them; otherwise, blankets and sheets will do. Bedding is one of the more difficult items to provide for people at a mass shelter.

4. **Clothes**—Pack a suitcase with extra clothing; take plenty of warm clothes if cold weather is a possibility.

5. **Toilet Kit**—Bring all the normal toilet articles you'd take with you on a trip.

6. **Medication**—Aside from any over-the-counter drugs such as asprin that you may need, bring any prescription drug used on a regular basis. This is especially important for anyone requiring daily medication such as thyroid supplements or insulin.

7. **Transistor Radio**—This will keep you informed and entertained no matter where you are. Bring extra batteries.

8. **First Aid Kit**—See Chapter 18. Bandaging and taping materials as well as other common first aid items are often in short supply in an emergency.

9. **Glasses**—Extra pairs of prescription glasses should be included if anyone in your family wears them.

10. **Special Foods**—Anyone who may need a special diet should bring his own food.

11. **Special Items**—Most people will have other things they want to bring along. For

example, valuable documents or papers should not be left behind if they could be damaged or lost.

12. **Games and Books**—Getting a game going or reading can help both children and adults pass the time and relax.

PREPARING YOUR HOME FOR EVACUATION

Before you drive off into the sunset, there are a few things you should do to insure that your home is as secure as possible. The steps to take depend a great deal on the disaster that has forced you to evacuate. Refer to the appropriate chapter in Section Two for specific instructions on each particular disaster. As a general rule, lock all doors and windows before leaving. If there is a threat of physical damage to your home, turn off the utilities (see Chapter 5). Remember that if the electricity is shut off, food in freezers or refrigerators will start to spoil in roughly two days. Food can be preserved longer by turning these appliances to their coldest setting before a power outage occurs and covering them with blankets or other insulating material. In general, try to protect and safeguard anything of value.

EMERGENCY EQUIPMENT FOR YOUR CAR

Adequately equipping your car will make travel easier and prepare you to handle difficult road conditions. In a disaster you won't be able to count on the Auto Club tow truck if anything goes amiss. You'll have to depend on your

knowledge and what you have with you. The type of equipment needed depends on expected weather conditions, types of roads to be traveled, remoteness of the area, and your mechanical expertise. Even if you're mechanically all thumbs it's valuable to have some basic tools and equipment in a car; someone else may have the knowledge to help. Here are the seven most important items to carry in a car:

1. **Hand-held Spotlight**—These handy spotlights plug into the cigarette lighter or connect directly to the car battery. They are the best source of emergency light for a car, whether it be to change a tire at night, look for something in a dark corner of the trunk, or see under the hood. They emit a powerful ray of light, roughly equivalent to a headlight beam, and come with a long cord that allows their use anywhere around the car. A flashlight is a poor second choice for emergency light. Batteries take a real beating in the high temperatures commonly found in a glove compartment or trunk. Hand-held spotlights will always work and provide many times more light than a flashlight. They are available at large retail and auto supply stores.

2. **First Aid Kit**—A first aid kit is invaluable for many roadside emergencies. See Chapter 18 on what to include.

3. **Tool Kit**—A few simple tools such as a hammer, crescent wrench, multiple screwdriver set, and pliers can cure many simple car ailments.

4. **Jack and Spare Tire**—Have a jack you know how to work, a tire iron large enough to turn the wheel lugs, and a road-worthy spare tire with air in it.

5. **Flares or Triangular Reflector**—Both of these are valuable in warning other drivers of a roadside emergency. It can sometimes be a bit tricky figuring out how to light a flare in a stressful situation; it's helpful to read the instructions on the flares prior to storing them in your car. A triangular reflector has the advantage of not being a fire hazard in case of spilled gasoline, but it is considerably more expensive than flares. Both can be found in large retail stores and auto supply shops.

6. **Battery Booster Cables**—Starting a stalled car using booster cables is much easier than trying a push start, and the cables are widely available.

7. **Water**—A plastic jug of water such as the kind sold in any grocery store can be kept for months and will furnish water for the radiator or to drink.

Winter Travel Equipment

Prepare for winter travel by equipping your car with snow tires and/or chains, a shovel, a windshield scraper, and a tow chain or rope. Have the car "winterized" before cold weather sets in. If you will be traveling in bad weather, it's advisable to have heavy gloves or mittens, a winter cap, proper footgear, and extra socks. A small hand-warmer or catalytic heater is also useful.

Remote Travel Equipment

If you travel on rough roads or in remote areas, carry extra equipment which will make you more self-sufficient. A supply of water, a small quantity of high-energy foods, a portable shovel, and extras for the car such as a fan belt or a quart of oil are all worthwhile. An emergency space

blanket is also a valuable item. These are lightweight, compact, and provide insulation and protection against hot or cold weather. They are sold in any large retail or sporting goods store.

DRIVING IN AN EMERGENCY

Leaving an area threatened by an emergency will be no Sunday drive if roads are jammed with traffic or bad weather makes traveling difficult. Nevertheless, a bit of knowledge and caution can get you through all but the worst road conditions. If you are forced to evacuate, follow official instructions and use recommended travel routes when possible. Your common sense and knowledge of the area will help you know the advisability of taking shortcuts. Remember that authorities may have information about road conditions which is unavailable to you. It's always helpful to carry road maps of the local area. If you do become stranded, stay with the car and the protection and resources it offers.

In a disaster, keep an eye out for road hazards such as downed power lines and broken streets or bridges. If possible travel during daylight and not alone. Avoid getting stuck: be wary of soft ground. Get out and check suspicious areas before driving on through. Keep driving at a steady speed without making any sharp turns if the ground suddenly feels soft under the tires. If the wheels begin to spin, stop immediately. Get out of the car and have a look at the problem. Spinning the wheels will only dig the tires in deeper.

Here's how to handle some of the situations that may occur during emergency travel.

Flooded Roads

Prior to driving through flooded areas, check the depth of the water. Most cars can pass through water up to the middle of their hubcaps. Drive slowly, stay in low gear, and ride the clutch if you have one to keep the engine from stalling. Once you are through the water, brake frequently to dry the brake linings. Any car with a manual transmission can be moved a short distance even if it stalls. Simply put the car in first gear; then, by turning over the starter motor you can inch the car ahead.

Snowbound Car

1. Stay with the car for the protection it will furnish. Use your judgment about leaving a car to get help; it's easy to get lost walking in a snowstorm. You can signal that the car is stuck by attaching a cloth to the radio aerial, raising the hood, or using the emergency flashers. At night, use the interior light to make the car visible.

2. Use the heater only intermittently; your fuel will last longer that way. Always keep a window open on the downwind side of the car to provide a fresh flow of air. Using the heater with all the windows closed can be dangerous. Keep the tail pipe unobstructed when the engine is running. Keep warm by moving your arms and legs and slapping them vigorously.

3. Trying to dig out a stuck car can be an exhausting business, especially in cold weather. Work slowly at shoveling snow and don't overexert yourself.

4. Be alert for symptoms of hypothermia and frostbite (see Chapter 15).

Stuck Car

Take the following steps to free a car stuck in soft soil or sand:

1. Using a small shovel or whatever is available, dig out around the tire. Then lay a path of twigs or gravel to provide traction in the direction you want to go.
2. Lighten the car's load by removing any heavy objects. Have passengers get out and push.
3. Accelerate slowly and evenly, making sure the front wheels are pointed straight ahead.
4. If the car is still stuck, get out, enjoy the scenery for a moment, and then try these other tricks that may free up the car. Let a little air out of the trapped tire to get more traction. Or, jack up the car and put gravel or twigs completely under the troublesome wheel. If nothing else works, "rock" the car back and forth by quickly shifting from forward to reverse to build up enough momentum to break the car free.

A FEW FINAL WORDS ON HIGHTAILING IT

Stay calm and use the information in this chapter to decide what actions to take if an evacuation is required. It's worth repeating that in an emergency, saving lives is the most important goal. All decisions should be weighed with this in mind. People are far more important than property or "things".

SECTION 2

IF THE TIME EVER COMES

CHAPTER 9

Heavy Weather

The sleepy Gulf Coast towns of Bay St. Louis, Pass Christian, and Gulfport stretch along the Mississippi coast east of New Orleans. The quiet life there is shattered periodically by hurricanes that once every few years redesign the local geography. People in these parts are familiar with such storms, so there was little reaction in August of 1969 when a hurricane moved into the Gulf of Mexico. Its name was Camille.

As late as the day before Camille struck, no one quite imagined what lay in store. In fact, it was a typical Saturday night in Gulfport, the largest of these towns, where tourists crowded the beachfront bars and restaurants, seeking relief from the hot, muggy weather. Little did anyone realize that this was to be the last night of business for these establishments. Hurricane Camille, somewhere out in the Gulf, was predicted to hit the Florida Panhandle in a day or two. It looked as though at least this time the Gulf Coast would be spared.

During the night, however, Camille gathered strength and shifted her course westward towards the Gulf Coast. By morning, many who had experienced hurricanes before packed their belongings, boarded up their homes, and headed north for safety. By noon, with more

ominous weather warnings arriving by the hour, a full-scale evacuation was under way.

As evening fell, the Gulf Coast was nearly deserted. Those who remained prepared for the long night ahead with a growing sense of alarm. The final weather service forecast predicted Camille would make landfall directly at Gulfport. The storm now packed winds at the unbelievable speed of 190 miles per hour, with gusts to 210 m.p.h. As the night began, the wind steadily gathered force, rising to a deafening howl. Rain pelted down from an ink-black sky and the ocean swept inland, eventually rising twenty-five feet above the normal high-tide mark. Shingles, tree limbs, and debris of every description filled the air. Houses and buildings shuddered and gave way under the assault. Shortly after 11 p.m. the eye of Camille passed over Pass Christian, providing a few moments' respite. Then the winds, now edging towards the 200 m.p.h. mark, resumed. Before the long night ended,. scores of tornadoes spawned by Camille swept across the hurricane's wake, adding to the damage.

It was mid-morning the next day when the first helicopters and amphibious vehicles arrived under cloudless skies to begin the rescue effort. The destruction was total. Every single building along the coast had been damaged or destroyed. Nowhere was the destruction more complete than in the first half-mile inland, where virtually nothing was left standing. The only remains of the scores of luxury homes along the coast were broken foundations. Two huge ocean liners lay hard aground, propped against each other. A grand piano sprawled upside down across the twisted railroad tracks. The four-lane highway along the coast had disappeared in places.

For days afterward, rescue workers and returning residents struggled to salvage what was

left. There was no electricity, telephone service, or public water supply. Transportation and communication remained difficult. Thousands of people were hastily inoculated against typhoid. With remarkable cooperation, everyone pitched in to help rebuild their communities.

The people of the Gulf Coast had weathered the most powerful storm ever recorded in the U.S. But Camille was not through. The greatly weakened storm swept north and then turned east, gathered strength again, and dumped ten inches of rain in the mountains of Virginia and West Virginia, causing major floods. All in all, Camille's rampage cost three hundred lives and over one billion dollars in property loss.

Camille was certainly not an average storm. Nevertheless, strong storms do strike each year in every section of the U.S. Whether you encounter hurricanes, tornadoes, thunderstorms, winter storms, or floods, you need to know how to prepare for and protect yourself against them. While each of these storms presents a different challenge, there are several preparations to take before any of them strike.

GENERAL PREPARATIONS FOR ANY STRONG STORM

1. *Prepare For A Power Outage*—Check to see that you have fresh batteries for your transistor radio and flashlights. If the storm may last for any length of time, stock up on candles and batteries or fuel for your lantern (see Chapter 3).

2. *Water*—Fill all available containers with water before the storm hits, as water supplies are frequently contaminated or disrupted (see Chapter 14).

3. *Food*—Stock up on several days' worth of easily prepared food that doesn't require cooking (see Chapter 7).

4. *First Aid*—Check your first aid supplies. In particular, have on hand any medications needed by your family (see Chapter 18).

5. *Firefighting Equipment*—Be prepared to fight a fire in your home, as fire is often a problem in the aftermath of a storm (see Chapter 6).

6. *Outside Help*—Find out how to get outside help. Food, clothing, and shelter, if needed, can be obtained at the nearest community shelter. Listen to the radio for its location.

7. *Passing The Time*—Gather together books, games, cards and puzzles to help pass the time. In spite of the stress of a long storm, much of the time you may be just plain bored.

HURRICANES

From a weather satellite a hurricane appears as a huge circular storm hundreds of miles in diameter. At the heart of this tempest is a calm inner core called the 'eye'. Rotating around this tranquil center is a maelstrom of raging wind and torrential rain. This huge energy system moves forward at 10 to 20 m.p.h., unleashing its enormous destructive power. Its path is unpredictable: it may swerve, backtrack, or loop around.

A hurricane depends on the ocean for strength, and it expends its greatest fury as it comes ashore. When a hurricane hits land, it drives a wall of water ahead of it called a storm surge. Lifted by the hurricane-force winds, the ocean rises as much as twenty feet or more over

the high-tide mark. As the storm moves over land it sweeps up anything in its path, filling the air with flying debris and causing great destruction. Once ashore the winds weaken rapidly and lose much of their punch. Nevertheless, even after the winds diminish, the hurricane may still contain enough moisture to flood areas hundreds of miles inland. In addition, a hurricane may spawn tornadoes around its fringes that add to the damage.

WHERE HURRICANES STRIKE

Hurricanes breed in the late summer or early fall over the warm waters of the Gulf of Mexico, the Caribbean, or the Atlantic. They may strike at coastal areas from New England to Florida and west to Texas. Low-lying seacoast regions are the most vulnerable. A hurricane begins as a "tropical storm" and is christened with a name. When its winds exceed 73 miles per hour it becomes a full-fledged hurricane. The newly born hurricane usually wanders in the ocean for several days. Depending on its path, it may head for land or drift into colder northern waters and dissipate.

PREPARING FOR A HURRICANE

Fortunately, word of a hurricane's approach is usually received in advance. The weather service keeps a close eye on all hurricanes. When the storm moves to within 24 to 48 hours of possible landfall, a "hurricane watch" is announced. When a hurricane is certain to hit land within 24 hours, a "hurricane warning" is issued, and threatened areas put emergency plans into operation. It's difficult to predict exactly where a

hurricane will strike; consequently, it is often necessary to alert residents along hundreds of miles of coastline. With this advance warning, almost all loss of life is now preventable.

In addition to the general preparations outlined at the beginning of this chapter, take the following steps for protection if a hurricane threatens your community.

1. Listen to your radio and keep a close watch on hurricane developments.

2. Prepare for the possibility of an evacuation and if asked to leave, do so without delay (see Chapter 8).

3. Put away or tie down all objects such as trash cans and lids, garden furniture, barbecues, awnings, children's toys, etc. This not only keeps loose items from ending up in the next county by the time the hurricane is over, but also prevents them from becoming potential flying hazards. As further protection against the wind, cover all windows with storm shutters or plywood to prevent the glass from being shattered. You may also want to brace or board up the doors. Park your car in a garage or under shelter.

4. Turn off your water supply before a storm hits to keep contaminated water from entering your pipes. If flooding or severe damage to your home is likely, turn off the electricity and gas as well (see Chapter 5).

5. Check your emergency supplies.

WHAT TO DO DURING A HURRICANE

Once the storm is upon you, stay indoors, as the winds will be too strong to contend with. In

addition, the air will be full of flying objects that are as dangerous as shrapnel. When the eye of the storm arrives, the winds will cease and the sun may even peek through. Don't be deceived; the winds will soon resume with equal force but from the opposite direction. The eye of the storm is only a few miles across, so unless the center of the storm passes directly overhead you may never see it.

What To Do After A Hurricane Passes

Use the information in Section 3 to guide you through the aftermath of a hurricane. Because there is often major damage to water and sanitation systems, you must be particularly careful of any water you drink. If your community is in the South and lies near a swampy area, be watchful for poisonous snakes that have been washed from their normal habitat.

Trailers and Mobile Homes

Although trailers and mobile homes are designed to be moved around, flying through the air is not exactly the preferred mode of transportation. Unfortunately, that's exactly what may happen when hurricane-force winds push broadside into a sixty-foot mobile home. A mobile home needs to be properly secured with cables to minimize the chances of this happening. Insurance companies and many zoning codes often require that mobile homes be tied down. For information on how to do this, write for a booklet from the Government Printing Office:

> "Protecting Mobile Homes From High
> Winds" DCPA TR-75
> Superintendent of Documents
> U.S. Government Printing Office
> Washington D.C. 20402

The cost is seventy cents.

Even with the best precautions, a trailer or mobile home is still vulnerable in a powerful storm. It's best to evacuate to the security of a more substantial shelter.

TORNADOES

Tornadoes are the most violent type of weather on earth. During its brief life a tornado leaves a path of destruction wherever it goes. The power of this rapidly spinning funnel of air is enormous, and mere man-made structures are no hindrance to its progress. It derives its strength from both the terrific winds and the partial vacuum at its core, which creates a tremendous suction effect on anything it passes over. Consequently, a tornado can blow trains off their tracks, toss cars about in the air as if they were toys, uproot large trees, and demolish most buildings. No one knows for sure just how powerful the winds in a tornado really are, as weather instruments aren't built for measurements like this. Most estimates place the winds at well over 300 miles per hour. A tornado's path is narrow, usually no more than a few hundred yards in width. After a tornado rampages across the earth's surface for a few miles it retracts back into the thunderhead where it originally began and disappears. The course it follows is random. Although the funnel's forward speed varies from almost stationary to as much as 70 m.p.h., most whip along at 30 to 40 m.p.h.

WHERE TORNADOES STRIKE

Tornadoes are an American phenomenon. Although they do occur occasionally in other parts

of the world, it is in the central plains of the U.S. where they are most common. The best known area is "Tornado Alley," stretching from Texas north into Kansas. However, tornadoes have touched down in all fifty states.

Even though tornadoes can strike anywhere at any time, there are some general features that characterize the majority of twisters. Most occur between noon and midnight and move in a southwesterly to northeasterly direction. Tornadoes are most likely to be generated in the plains when warm, moist air from the south collides with cool, dry air in the north during spring and early summer. This creates a regular tornado season in the South and Midwest. The center of tornado activity is over the Gulf states in February, moving east to the Atlantic states in late March and April and up to the southern plains states in May. By June the greatest danger lies in the northern plains and Great Lakes areas and even as far east as western New York State.

PREPARING FOR A TORNADO

Your best protections from a tornado are early warning and adequate shelter. The National Weather Service has developed an intricate system to monitor possible tornado danger. A network of weather stations, weather satellites, and radar installations combine to give forecasters a good picture of potential tornado activity. In areas of the Midwest where the danger is particularly high, a network of private citizens known as SKYWARN scans the horizon during times of danger and reports to the Weather Service any sightings of funnel clouds. Commercial radio and television stations cooperate to get this information to the public. Tornado alerts take two forms:

Tornado Watch A tornado watch is declared whenever there is a potential of a tornado developing. If a tornado watch is announced, make preparations to seek shelter and continue listening to the radio for new developments.

Tornado Warning When a tornado is actually sighted, either visually or on radar, a tornado warning is issued. The current location of the funnel cloud, its probable direction of movement, and the approximate time it is expected to strike certain areas will be given. If a tornado warning is announced, prepare to take cover immediately.

A battery-operated radio is essential for keeping abreast of weather developments in tornado-prone regions. In addition, a weather radio with a warning alarm is particularly useful for getting early word of a tornado (see Chapter 4).

SHELTER FROM A TORNADO

If you live in a high-risk tornado area you should know where to take shelter both at home and at work. The best place to find protection is in a basement or storm shelter. If that is not possible, take cover in the center of the lowest floor in the strongest building available. A small room such as a bathroom or closet offers the best protection. Crouch under sturdy furniture if possible. Position yourself well away from doors, windows and outside walls. Open a few windows to help equalize the very low air pressure of the tornado.

Cars, trailers and mobile homes are no place to be if a tornado threatens. Seek more solid shelter elsewhere. Large buildings with wide-span roofs such as gymnasiums, auditoriums,

and large stores in shopping centers are also unsafe. These large roofs are more likely to give way to the tremendous suction of a tornado. For the same reason, large school buildings are often unsafe. Educators need to have well thought-out and practical plans for what to do if a tornado watch is issued.

If you are caught outdoors, move at right angles away from the tornado to evade it. Take cover by lying flat in a ravine, ditch or culvert if the tornado is too close to escape.

An approaching tornado sounds like an express train. As it moves closer, cover your head to protect yourself from flying debris.

What To Do Following A Tornado

Once the twister has passed, keep a sharp lookout for more tornadoes. Where there is one, there may be more. Next, turn your attention to helping any people who are injured. Search carefully for victims under debris and on both sides of the tornado's path. Tornado victims are often covered with mud, so be sure not to overlook any of their injuries. The jumble of debris combined with broken gas mains and electric lines create a real fire hazard. Turn off the electricity and gas if necessary.

THUNDERSTORMS

The familiar towering cumulonimbus clouds that signal the beginning of a thunderstorm are formed by rapid updrafts of warm, moist air—most frequently on summer afternoons. Thunderstorms are violent but usually short in duration. While they last, they present the danger of high winds, heavy rain, hail, lightning, and lightning fires.

PREPARING FOR A THUNDERSTORM

A hot, sultry afternoon is often a prelude to a thunderstorm. The warning signs include the formation of heavy, dark clouds, a sudden drop in temperature, and an increase in gusty winds. Your best protection against the strong winds, hail, and lightning is to seek shelter in a well-constructed building. Before the storm hits, tie down or take inside objects that could blow away. Prepare for a power outage. If you are in a tornado-prone area, listen to the radio for news of a tornado watch.

LIGHTNING

Lightning is the deadliest aspect of a thunderstorm. It is caused by a strong discharge of electricity from storm clouds to other clouds or from clouds to the ground. The thunder that follows is the result of the explosive expansion of air that is heated by the lightning. To estimate how many miles away the lightning is striking, count the seconds between the flash and the thunder and divide by five.

Contrary to myth, lightning can strike in the same place more than once. In fact, it may strike a lightning rod or a tall building several times in the course of a single storm. The best way to prevent getting zapped by lightning is to seek shelter inside a building or car. If you take cover indoors, do the following things to insure your safety:

1. Stay away from windows, fireplaces, heavy metal objects, and metal pipes such as the plumbing in sinks or showers. Close all windows and doors.

2. Don't use electrical equipment or the telephone.

 Lightning seeks out the tallest objects in the area. If you are caught outside, head for a canyon or ditch, or the lowest terrain available. Golf clubs, bicycles, fishing poles, and other metal objects all attract lightning and should be discarded immediately.
 Water is one of the worst places to be in a thunderstorm. A boat or even a swimmer is the highest object on flat, open water and is therefore a likely target. Head for shore at the first sign of a thunderstorm. Other places to avoid during a thunderstorm include hilltops, open spaces, poles or isolated trees, fences, clotheslines, train tracks, and overhead wires.

How To Help Someone Struck By Lightning
A person struck by lightning receives a strong electrical shock and possible burns. The electrical charge dissipates instantly so there is no danger in touching the victim. Being struck by lightning may cause a person's heart and breathing to stop. Prompt use of cardiopulmonary resuscitation (CPR) can revive the victim. If you are not trained in CPR, at least attempt mouth-to-mouth resuscitation (see Chapter 19). Treat other injuries or burns and see that the victim gets medical attention.

What To Do Following A Thunderstorm
Check for damage around your home once the storm is over. In doing so, avoid any downed electric power lines. Use your radio to listen for flash floods or tornadoes if they are a threat in your region.

WINTER STORMS

Each winter, heavy snows, cold weather, and blizzards paralyze various parts of the country. These winter storms, with their snow, ice, wind and rain, demand that you be self-sufficient in order to withstand their disruption of normal life. Except in the deep south and in a few western states, the hazards of winter storms are just part of living.

The National Weather Service issues alerts for hazardous weather conditions. Blizzards, the most perilous of all winter storms, bring heavy snow, high winds, and low temperatures. In areas of the country subject to blizzards, the following alerts are issued:

Blizzard Warning This means that a snowstorm is expected in which there will be winds of at least 35 m.p.h., considerable falling and/or blowing snow, and a temperature of 20° F. or less over an extended period of time.

Severe Blizzard Warning This indicates a heavy snowstorm with winds of at least 45 m.p.h. and temperatures of 10° F. or less.

PREPARING FOR A WINTER STORM

Staying warm and handling the isolation that heavy snow will bring are the biggest challenges in a winter storm. Once the storm settles in, it may be several days before outside help can reach you. Since storms can brew up quickly, advance planning is important. Besides the general preparations listed at the beginning of this chapter, the following steps will help you outlast a lengthy storm:

1. *Heating Fuel*—If you use heating oil, coal or wood, always keep an adequate supply on hand. When the power is knocked out, some types of furnaces and all forced air heating cease to function. You should have some type of emergency heating such as a catalytic heater, or an extra supply of wood for a fireplace, to keep at least one room warm (see Chapter 15).
2. *Winterize Your Car*—Besides the usual preparations of chains, antifreeze, etc., carry equipment to keep you warm and well in case you are trapped by a storm (see Chapter 8).
3. *Check your emergency supplies.*

WHAT TO DO DURING A WINTER STORM

Follow the example of a hibernating bear during severe weather: stay indoors and do as little as possible. If you do have to go outside, dress warmly with many layers of protective clothing. Reserve traveling for emergencies only. Remember that shoveling snow is extremely strenuous work in cold weather.

FLOODS

A flood is water that inundates normally dry land. Floods can be extremely destructive, washing away buildings and farmlands alike and completely disrupting normal life. In addition, fires and contamination of water supplies are common problems in a flood's aftermath.

WHERE FLOODS OCCUR

Floods usually occur on low-lying sections of land appropriately called floodplains. A floodplain is the lowland bordering a river; it is often several miles wide. Since such bottomlands have rich soil, they are usually heavily populated. Floods most frequently occur after heavy rains or in the spring when there is a rapid melt-off of snow and ice. Seacoast areas are subject to flooding from the effects of a strong storm such as a hurricane. There is also a potential flood hazard to any area located below a dam.

Unless your home is on a mountaintop, it's a good idea to check with authorities to ascertain the likelihood of flood danger. Your local planning office or the U.S. Geological Survey has maps showing the flood potential in your locality. People living on a floodplain need to be well aware of the possible danger and prepared to deal with it. Flood insurance is often required by lending institutions on buildings in high-risk zones.

HOW TO PREPARE FOR A FLOOD

With enough warning that high water is on the way, you can protect yourself and minimize your losses. It doesn't take forty days and forty nights of rain to make a flood. In fact, you may not even see a drop of rain if strong storms many miles away cause a river to overflow. The National Weather Service issues a flood warning for any area where there may be trouble. The warning tells where and when the flood is expected and its probable severity. Listen to the radio or television for these warnings, and in addition to the general preparations listed at the

beginning of this chapter, take the following steps if a flood is expected in your area:

1. Keep up with the latest information from authorities. Fill your car's gas tank if evacuation is a possibility. When in doubt, evacuate; don't wait until roads are flooded and impassable (see Chapter 8).
2. Obtain sandbags if you are going to need them. Feed and ranch supply stores often have extra burlap bags; if not, local authorities can tell you where to get some.
3. Check your emergency supplies.

WHAT TO DO IF YOU RECEIVE A FLOOD WARNING

If authorities issue a flood warning for your area, remember that evacuating while there is still time takes precedence over all other measures. Here is what you should do before leaving, if possible:

1. Shut off your water supply to prevent contaminated water from entering your pipes. Turn off the other utilities if there is a chance of flooding in your home.
2. Put as many things as you can up on counters and tables before leaving a one-story home. In a multi-story home, move valuables to the highest floor.

WHAT TO DO DURING A FLOOD

Once you are safe from the flood waters, take these precautions:

1. Unless authorities have assured you that the water is drinkable, play it safe and purify it (see Chapter 14).

2. Assume that food and cooking utensils that have come in contact with flood waters are contaminated. Discard any food that is questionable, and thoroughly wash any cooking utensils before using them.

3. Don't touch any "live" electrical equipment if you are standing in water. Dry out any wet electrical appliances and have them checked before using them.

4. Look for fire dangers such as gas leaks or spilled flammable liquids.

FLASH FLOODS

A flash flood is distinguished from a regular flood by its suddenness. Although flash floods can happen anywhere, they are most common in mountain canyons, dry creek beds, and arroyos. The tremendous power and speed of a flash flood can sweep away virtually everything in its path. A sudden thunderstorm or heavy rain, a dam failure, an earthquake, or an ice-jam breakup can all cause flash flooding.

The National Weather Service watches this type of flooding condition closely and issues two types of alerts:

Flash Flood Watch This is an alert that heavy rains are expected or occurring and may result in flash flooding. If a flash flood watch is issued for your area, prepare to take needed action and listen to the radio for further news.

Flash Flood Warning This means that a flash flood is imminent for the areas designated by

the Weather Service. Move to a safe place on high ground immediately.

Preparing For A Flash Flood
If you live in an area where flash flooding occurs, preparations must be made now as there won't be time when the floods occurs. Get a clear understanding of what flood dangers threaten your home and find out how high streams and rivers have risen in the past. Know where high ground is and how to get there quickly as a "dry" creek bed can become a raging river in a matter of moments. Don't picnic or camp in lowlands that are potential flood zones. If a flash flood alert is issued, stay away from waterways, low spots, and bridges.

LANDSLIDES

Landslides have become an increasing problem as suburban sprawl has forced housing into more marginal regions such as sloping hillsides, mountainous terrain, and the area near seacoast cliffs. This is especially true in areas such as southern California, where many hillside developments are built on unstable mountain slopes. The seacliffs along the coasts of California and Oregon are also quite vulnerable to slope failures. Millions of dollars' worth of property has been lost in these areas as a result of landslides.

TYPES OF LANDSLIDES

There are a variety of different types of landslides. They include:

1. *Soil creep*—Soil creep is the slow downward movement of the surface layer of soil due to

the pull of gravity and natural erosion processes. The movement is slow and damage is usually minimal.

2. *True landslides*—A true landslide is downslope slippage of a block or blocks of soil and rock along a rupture zone. This is one of the most common and destructive types of landslides.

3. *Rockfalls*—Rockfalls are common along seacliffs and steep inclines. They occur when the sliding material free-falls directly to the ground.

4. *Earth flows*—An earth flow results from the downward movement of a section of earth that is saturated with water. Earth flows move at varying rates of speed and their mud and water can be very destructive.

FACTORS THAT CAUSE LANDSLIDES

Landslides usually occur as the result of a triggering mechanism such as:

1. *Water*—This is the most common cause of landslides. Water can saturate a hillside and soften the soil, weakening its cohesive properties. If the slope is already unstable, this can cause it to give way.

2. *Undercutting*—A man-made cause of many landslides is the undercutting of a bottom or "toe" of a potential slide area with a road or highway which destablizes the slope. Streams and rivers can also cause undercutting.

3. *Change in vegetation*—Soil that has lost its cover of vegetation is particularly susceptible to erosion and sliding. Areas that have

burned recently or have been cleared and not replanted are vulnerable, especially during heavy rains.
4. *Shocks*—Earthquakes and explosions produce vibrations that can destablize a slope and cause it to slide.

MINIMIZING THE LANDSLIDE DANGER

Avoiding areas prone to landslides is the key to minimizing the danger. When choosing a home, check for any indications that the land upon which the house is built is susceptible to sliding. Telltale signs that the ground is unstable include cracked walls, basements, or foundations, power poles or trees in the neighborhood that are tilted to one side, and cracks or ruptures in the streets. Also, check on slopes or cliffs above the house. If there is any reason to believe that a landslide hazard exists, talk with your local planning authorities. They will be able to give you an idea of past problems and advice on the potential risk in the future. The U.S. Geological Survey has maps of some areas, delineating the landslide danger.

Be prepared if you already live in a landslide-prone area. Do all that can be done in the way of retaining walls, drainage systems, etc. If necessary, keep a supply of sandbags on hand and know what to do if an evacuation becomes necessary (see Chapter 8).

WHAT TO DO DURING AND AFTER A LANDSLIDE

Any noticeable earth movement such as cracking or settling is a warning that a landslide may

be on the way. Get away from the danger area at the first sign of slippage as there is no way for the average person to determine the degree of danger that exists. The warning signs may indicate a slide is only minutes away or the signs may not mean much at all—only an expert can tell. Contact the public works department of your city or county government and have an engineer or geologist assess the problem. If you call early enough, they may be able to determine what is causing the slippage and to provide a remedy such as additional drainage systems.

If you are caught in a sudden landslide, the only thing you can do is run at right angles from the slide to get out of its path. A large landslide can plunge downhill at well-over one hundred miles per hour and cover a surprisingly large distance. Once the landslide is over, be exceedingly careful in re-entering the damaged area, as more slides may occur. Check for broken gas and electric lines, and shut off the utilities if necessary (see Chapter 5).

CHAPTER 10

Fire!

Chicago in 1871 was a bustling and growing metropolis. In early October Mrs. O'Leary's uncooperative cow kicked over a lantern, touching off the blaze that became known as the Great Chicago Fire. Much of the city was destroyed and the story of the fire gained a permanent place in the history books. By a remarkable coincidence, at the very hour that downtown Chicago was going up in smoke, a far more serious fire was raging just a few hundred miles to the north. Virtually forgotten today, the Peshtigo Fire burned huge sections of both Wisconsin and Michigan, destroyed a number of towns, and claimed 1,500 lives. It still remains as America's worst fire disaster.

The cry of "Fire!" has the same meaning today as it did for the victims of these twin tragedies a century ago. In spite of modern technology, fires of all types take a large toll in property and lives each year. Fires often accompany other disasters as well. Hurricanes, tornadoes, floods, lightning storms, and earthquakes can all leave a trail of fire in their wake. Learning how to minimize the chances of fire and what to do if one breaks out greatly enhances your fire protection.

THE DANGERS OF FIRE

The smoke, not the actual flames of a fire, presents the greatest danger in a blaze. Most fire victims are overcome by smoke long before the flames get to them. Smoke is a combination of a number of highly toxic gases that can cause a person to lose consciousness in a matter of moments. Thin wisps of smoke can be just as deadly as the heavy, black, oily variety. Some modern materials emit lethal fumes that are invisible and virtually odorless. One of the reasons the majority of fire fatalities occur at night is that sleeping victims are overcome with smoke and never even wake up.

The speed with which a blaze can spread is the other great danger. A small fire can become an inferno in a matter of moments. The heat generated can blast through a building and spontaneously ignite other parts of the structure. Plastics and synthetic materials commonly found in modern buildings are often highly combustible. Multistoried structures present an added danger in that superheated air can roar up stairwells and vents as if they were chimneys.

Even people who have taken the best precautions may find themselves in a burning structure. It can happen in the familiarity of their own home or in a strange building or hotel. Wherever it occurs there are a number of things a person can do.

STRUCTURAL FIRES

What to Do in a Burning Building
1. **Escape**—Keep in mind that smoke and superheated air are the main enemies and that escape, not fighting the fire, is the most important priority.

2. **Stay Low**—Smoke and heat both tend to rise. By crouching low to the floor you can take advantage of the coolest and purest air in the room. Don't worry about looking graceful; crawl if necessary. Cover your mouth and nose with a handkerchief and breathe slowly with short careful breaths.

3. **Test The Doors**—A door can furnish a very effective barrier against a fire, holding back heat and deadly smoke for a number of minutes. Smoke drifting under a door may signal an inferno on the other side. Before jerking open a door it pays to "test" it. First, look for signs of smoke and listen for the sound of fire. If the door panels or the knob are warm to the touch, find another way out. Even if the door doesn't feel warm, open it carefully if you suspect a fire on the other side. The superheated air and smoke of a fire build up tremendous pressures that can blast into the room when the door is opened. Brace your body against the door and open it just a crack. Be prepared to slam it shut again.

4. **Using The Window**—If smoke or flames have you trapped in a room, the only escape may be through a second- or third-story window. Going out a window should be considered a last resort if it's above the first story. There's no point in making your exit any more dramatic than necessary. Try to wait for the fire department to rescue you. Signal that you need help by yelling and waving a sheet or towel out the window. Keep the window slightly open to get fresh air while you wait. If you can, knot together sheets and blankets to form a makeshift rope. If you are forced to go out the window, hang from the window sill and drop to the

ground. Try to break the fall by landing in bushes or soft dirt. When hitting the ground, relax and try to absorb the shock of the impact throughout your body.

5. **Close Doors**—Closing doors behind you as you leave a burning building will cut off air to the blaze and slow the fire's advance.

6. **Alert Others**—At the same time you are getting out, let anyone else in the building know a fire is out of control. Shout "Fire," pound on walls and doors, and raise as much of a ruckus as you can.

7. **Call The Fire Department**—Use a phone in the building only if you're positive you can get out safely and won't be overcome by smoke. Otherwise, use a phone in a nearby building or a corner alarm box. Pull the fire alarm system if the building has one. Don't assume that the fire department has been notified; call them yourself or make sure someone else does it.

8. **Once You're Out, Stay Out**—Don't gamble on escaping the fire twice. No one should re-enter a burning building except under extreme circumstances.

9. **Assist The Fire Department**—Have someone out in front to meet the firefighters when they arrive. This person should direct firefighters to the scene of the fire, especially in an apartment or office building. Let the firefighters know if anyone is still in the building.

Fire In A High-Rise Building

Most skyscrapers are not likely to erupt into an inferno. Tall buildings are built to confine a fire to the apartment or office in which it starts. In addition, skyscrapers have automatic sprinkler

systems and are constructed with materials that resist fire. Nevertheless, a high-rise fire presents special problems. If the hallway is filled with smoke, a person on the twenty-third floor can't simply hop out the window.

The first priority in a burning high-rise is to get out. Multi-storied buildings will have either internal fire-resistant stairways or external fire escapes. There will be several routes down from the building, so if one is blocked another may be open. Alert others as you leave and close all doors behind you to slow the spread of the fire. Don't use an elevator in a fire as you might get trapped. If all avenues of escape are blocked, barricade yourself in the room. Shut the door firmly and cover the cracks around it with wet towels or rags to prevent smoke from entering; a tightly-shut door presents a substantial barrier to the spread of a fire. Stay close to a slightly open window to get fresh air and call for help.

YOUR FAMILY ESCAPE PLAN

In the event of fire, have a plan of action ready for your home. If you work out this escape plan beforehand, everyone will know what to do if awakened to a house full of smoke and fire. The escape response should be automatic. Getting out fast is the key, especially in a night fire. No one should be stopping for valuables or to save pets. Your plan needs the following elements:

1. **Two Ways Out**—Have two ways out of every bedroom. That may mean figuring out a way to get down from a second- or third-story window. One solution is a collapsible escape ladder that can be stowed under a bed or in a drawer. These are sold at large retail stores. Make sure all windows can be

easily opened and are not blocked by screens or shutters.

2. **Meeting Place**—Set up a prearranged meeting place for everyone to go to in case of fire. It can then be quickly determined if everyone got out safely.

3. **Fire Education**—Teach your family what to do in the event of a fire. They should know to shut all doors behind them, how to escape from a smoke-filled room, how to test a door, and how to call the fire department.

FIRE EDUCATION FOR CHILDREN

Teach all children in your home the dangers of fire and how to protect themselves against it. Small children sometimes try to hide from a fire by crawling into a closet or under the bed. Your children should know how to react if the smoke detector goes off or if they wake up with their bedroom filled with smoke. Discuss with your children how to escape from a fire and where to meet you. A fire drill is a very good way of letting children practice what they've been taught.

It is also important to talk about fire prevention, especially the danger of playing with matches. In addition, teach your children to roll, not run, if their clothes catch on fire. Children, like adults, should know how to report a fire. Any child who can carry on a conversation is old enough to call the operator for help. Instruct older children to dial the fire department directly.

HOW TO PUT OUT A SMALL FIRE

Escaping from a fire and calling the fire department are the two most important actions to take.

Nevertheless, it's worth trying to put out a small fire yourself, while keeping a clear escape route open: overpowering smoke and high temperatures can build up very quickly.

A small fire can be extinguished several different ways. A multipurpose fire extinguisher is the best method, furnishing reliable protection against any type of fire. If no extinguisher is available, you can use water from a bucket or hose, provided the fire doesn't involve electricity, grease, or oil. Smothering is also very effective. Covering a burning pan or throwing a heavy rug on a small blaze can quench the flames. A burning object such as a smoldering pillow can be pulled out of the building and then doused.

With whatever method you use to fight the fire, *stay low*, crouching out of the way of heat and smoke. Be watchful of flare-ups and explosions. If you are dousing the flames with an extinguisher or water, aim for the base of the blaze. Call the fire department even if the fire is successfully put out. A fire can slip into walls or smolder unnoticed in a mattress and reappear hours later. Professional firefighters know what to look for and will make sure the blaze is out.

If a person's clothing catches on fire, quick action must be taken. The natural impulse is to run, but this is the worst thing to do. Have the victim lie down and roll. If a rug, blanket or coat is nearby, use it to smother the flames. Give the victim first aid for burns and shock.

HOW TO HELP SOMEONE
WHO IS OVERCOME BY SMOKE

Even a few lungfuls of smoke can render a person helpless and perhaps unconscious. A person suffering from smoke inhalation needs

immediate first aid. Symptoms include violent coughing, irregular breathing, nausea and dizziness. The victim may even be unconscious and not breathing.

Treatment
1. Get the victim into the fresh air immediately.
2. Give mouth-to-mouth resuscitation if the victim is not breathing, and treat for shock (see Chapter 19).
3. Take the victim to a doctor or hospital to be checked even if they seem to recover. Inhalation of smoke particles can cause problems in the lungs and bronchial tubes. A doctor may also want to test for carbon monoxide poisoning.

FIRE PREVENTION

The best way to fight a fire is to prevent it from happening in the first place. There are a number of simple steps you can take that will dramatically lower the odds of your ever suffering the ill effects of a fire. The following three items form the cornerstone of your fire prevention program:

1. Post the phone number of the local fire department by your phone (see Chapter 2).
2. Install a smoke detector and fire extinguisher in your home (see Chapter 6).
3. Have a family escape plan.

The guide for fire prevention can never be complete for there are so many different ways a blaze can start. Here are five of the most important items to check:

1. Keep the garage, attic or basement free from piles of old newspapers, oily rags, or assorted junk.

2. See that the wiring in your home is right for the job. Don't run cords under carpets or hang them from nails. Avoid plugging too many appliances into one socket.

3. Store paints and solvents in closed metal containers away from heat sources. If you must store gasoline, keep it well away from any building.

4. Have the furnace serviced before each winter to be sure it's in good repair.

5. If there is a smoker in the house, that person should be aware of the special hazards of cigarettes. Smoking in bed or when sleepy is a prelude to trouble. Careless smoking is a major cause of home fires.

GRASS, BRUSH OR FOREST FIRES

Glowing flames on the horizon and clouds of smoke towering into the sky are convincing proof of the awesome power of an uncontrolled fire. Every year grass, brush, and forest fires rage through parts of America's wildlands. Some of these fires start from lightning but all too many are caused by man's carelessness. Whether natural or manmade, a large fire poses a threat to homes and buildings in its path.

Weather greatly affects how a fire will move. Hot, dry, windy weather is the nemesis of the firefighter. In the East, the fire season tends to occur in the spring and fall while in the West the dry, late summer months are the worst. The direction in which a fire will spread and how destructive it will be depend on the terrain, the

type of vegetation, wind, humidity and weather conditions. Given the right combination, flames can easily leap 150 feet in the air and move with lightning speed. How the fire starts also affects the way it burns. Lightning fires usually start at the top of a mountain where there is less to burn and the air is cooler. On the other hand, man-made fires often begin along roads or trails and work their way upwards with terrific speed and destruction.

PREPARING FOR A FIRE

If you live in an area where a grass, brush, or forest fire is a threat, it's sensible to make some preparations and know what to do if a fire should occur. It's important to know all the different escape routes from your home and a safe place to go if a fire did sweep through the area. A fire can move all too fast for comfort and flying embers borne on the wind can carry ahead of the main fire and start new blazes.

People living in a fire danger zone should keep the area immediately around their buildings clear of brush and anything else that will burn. In fact, the law often requires this. Non-flammable roofing materials, although usually not required, are best for a fire area. As attractive as shake roofs are, they ignite easily from sparks and cinders and are often the first to burn.

WHAT TO DO IN A GRASS, BRUSH OR FOREST FIRE

If a fire is raging out of control, your main concern is to get away from it. Leave the firefighting to the hotshot crews and aerial bombers. Anti-

cipate how a fire will burn; flames move fastest uphill and downwind. Take the following six steps if a fire threatens your area:

1. Report the fire to the forest service or local fire department. Don't assume that someone else has called the authorities.

2. Make plans for leaving the area in a hurry if it becomes necessary (see Chapter 8).

3. Keep informed of events by listening to the radio or television.

4. Clear away anything flammable near your home and use a garden hose to wet down the roof and surrounding area to protect against flying sparks and cinders. Close all windows and doors.

6. If you are forced to flee a fire, try to get out of the path in which it's headed. Going downhill and upwind will usually take you away from a fire.

CHAPTER 11

Earthquakes and Tsunamis

EARTHQUAKE

The first morning light had just begun to color the hills in the east near Los Angeles. Further west the San Fernando Valley lay covered in pre-dawn darkness. The stillness evoked memories of how the valley had been two decades ago when the orange groves first began to give way to the postwar building boom. Now the trees had been replaced with tract houses. A few people were stirring in these homes, preparing for another working day. Little did they imagine what sort of a day it would be. The date was February 9, 1971.

Shortly after 6 a.m., deep within the earth, mammoth pressures reached the breaking point. The San Fernando Fault gave way, uplifting the San Gabriel mountains several feet. Like a mighty wave the reverberations from the earthquake swept across the valley. The noise grew from a low rumble to an awesome roar as the earth shook and trembled. Bridges and hospitals collapsed, windows shattered, chimneys tumbled, lamps, bookcases, pots, pans, and china were strewn in all directions as the earthquake wrecked its havoc on the land. Thousands

of people were tossed from their peaceful world of sleep into one that was literally crashing down around them.

In a minute it was over. Dust kicked up by the vibrating earth began to settle back on the surrounding foothills. The valley itself was strangely dark; the normal twinkling city lights had disappeared. Slowly the sun began to spread its light and to reveal the destruction the quake had caused.

The damage was widespread. Sixty-four people were dead, over two thousand were injured, and more than half a billion dollars in property was destroyed. Sections of Interstate 5 had collapsed. The Van Norman Dam was badly damaged and desperate efforts were being made to lower the water level behind the dam. Eighty thousand people in the endangered area were evacuated, their progress slowed by downed power lines and broken streets. For most of that day there was no electrical power, no water, and no gas. No phone lines were operating. Water and food had to be shipped into stricken areas.

As the inhabitants of the San Fernando Valley began to pick up the pieces it became clear that the damage could have been much worse. Had the earthquake struck just two hours later, with the freeways jammed with rush-hour traffic, many more lives would have been lost. The valley dwellers were also lucky that the Van Norman Dam held long enough for the reservoir behind it to be drained.

While the residents of the valley began to rebuild, people in other earthquake areas were breathing sighs of relief that at least this time it hadn't been them. A good number of people east of the Mississippi were thinking how lucky they were not to live in a place where the earth moved. Some undoubtedly would have been sobered to learn that destructive earthquakes

have shaken such unlikely places as Missouri and South Carolina. In fact, earthquakes have been recorded in every state of the union.

WHO NEEDS TO PREPARE FOR AN EARTHQUAKE

Earthquakes tend to occur most often along "faults" or cracks in the earth's crust. The west coast of North America contains many such faults, including the famous San Andreas Fault. California, as is well known, is especially prone to earthquakes. But just because you don't live in San Francisco doesn't mean it isn't necessary to make some simple preparations for an earthquake. Alaska, site of the devastating quake near Anchorage in 1964, has seen the largest number of major quakes of any state. Other states where there is a significant earthquake risk include Nevada, Hawaii, Montana, Oregon, Utah and Washington. Anyone living in these areas should be aware of what to do in case of an earthquake.

Some situations require special precautions. Trailers and mobile homes are liable to become uncomfortably mobile in a quake. Buildings whose foundations rest on landfill, old waterways, or other soft, unstable soil are also especially hazardous. People living very near or directly on fault zones should be well prepared.

PREPARING FOR AN EARTHQUAKE

Earthquakes strike without warning. There will be no chance to "batten down the hatches," evacuate or prepare in any way. Therefore it is essential that you make plans before an earth-

quake occurs. These preparations have the advantage of generally preparing you for many other emergencies as well. The following thirteen steps will considerably improve your ability to deal with an earthquake:

1. Locate all your utility shutoffs and learn how to operate them. See that other family members can do the same. Make sure that any wrenches needed to turn valves are readily available. It doesn't help to know where the shutoffs are if they can't be turned off. Be familiar with your utility shutoffs at work as well. (See Chapter 5 on how to do this, and use the tear-out pages to post this information in your home or workplace.)

2. Have good sources of emergency lighting on hand (see Chapter 3).

3. Always keep a battery-operated radio available and know what stations will provide information in an emergency (see Chapter 4).

4. Put together a home first aid kit that meets your special needs (see Chapter 18).

5. Depending on your situation, consider storing a small amount of water and food for emergency use (see Chapter 7).

6. Check around your house and workplace for heavy objects placed high on walls. Look carefully around your bed to be sure nothing can come crashing down on you while you sleep. Anything heavy in a bookcase should go as near the bottom as possible. If you have heavy air conditioning or heating units placed high on walls or in the

ceiling, see if they can be moved to a safer location.

7. See that your water heater is securely fastened. They frequently come tumbling down in an earthquake, severing gas or electric lines as well as breaking water pipes. A tall, upright water heater should be strapped or bolted securely to the wall. This is especially true if the water heater is located inside the house. Use flexible connections for gas lines.

8. Talk with your insurance agent about earthquake insurance. Most large insurance companies offer this type of coverage. People with a large equity in their homes may be particularly interested in looking into this.

9. Back efforts to enforce realistic building codes in earthquake areas. Make sure the buildings in which you spend the most time (home, office, or school) are up to code and don't present any obvious earthquake hazards. Don't buy or build on active earthquake faults. (Plenty of people in the West have done exactly that.)

10. Keep your immunizations up to date.

11. Take a first aid class (see Appendix 1).

12. Learn more about earthquakes (refer to Appendix 1). In addition, try to find out more about earthquake faults in the area where you live. The planning commission or local library should have maps of all nearby faults and possibly will have detailed information on previous local quakes.

13. Discuss earthquakes with your family and make sure everyone knows what to do.

WHAT TO DO DURING AN EARTHQUAKE

An earthquake strikes unexpectedly and with incredible noise and violence. When solid ground begins to tremble and shake it's enough to frighten even the hardiest of souls. But no matter how scared you become, if you know the right steps to take you can act constructively. Here's what to do if you're in the following places:

Inside A Building

Protect your head and body from flying glass and falling objects. If possible, take cover in a doorway or under a table or desk. Try to stay near the inside parts of the building. A large quake may generate such severe shaking that it will be impossible to move to a safer place. If there is no protection handy go into the "duck and cover" position by kneeling on the floor with your head tucked in front of your knees. Clasp your hands around the back of your head.

Don't yield to the natural impulse to dash outside. Most modern buildings will not collapse around you, although at the time it may seem that way. Stay well away from windows and chimneys. High-rise buildings may accentuate the ground motion by swaying back and forth several feet. Again, use a doorway or get under a desk or table. Watch for flying glass. Don't rush for the exit, and don't use elevators or stairways.

In A Car

A car provides a protective shell around you, so don't leave it. As soon as the earthquake is felt, pull to the side of the road and stop. Try to stay away from other cars. Don't stop under a bridge

or freeway overpass. Watch for fallen power lines; they can't hurt you if you stay in the car.

Outside
This is the safest place of all to be, provided there is nothing to fall on you. Contrary to Hollywood disaster movies, the earth will not split open and swallow you. In all the quakes on record there are only a handful of accounts where this was actually supposed to have happened. Stay in open areas away from buildings, walls, light poles or anything else that could topple. Be careful near power lines; don't touch anything that is in contact with one. On a city street, use the doorway of a building for protection.

IMMEDIATELY AFTER A LARGE EARTHQUAKE

There are three things that need to be done as soon as the shaking stops:

1. Check for injuries.
2. Check for fires and gas leaks.
3. Turn off the utilities if necessary.

Injuries
Check to be sure everyone you're with is all right. Give first aid to anyone who is seriously hurt (see Chapter 19). Minor cuts or scrapes can wait.

Fires And Gas Leaks
Take a quick look around for fires or the smell of gas. Put out any small fire with a fire extinguisher or smother it with dirt or blankets. Use a garden hose if water pressure is available. If

there is a gas leak or a fire too large to control, get everyone out of the building immediately. Try to call for help if the phone works.

Utilities

Turn off any utilities coming into the building, including gas, electricity, and water (see Chapter 5). It is essential to do this. Fires started from broken gas lines or electrical short-circuits cause great destruction after many quakes. In the 1906 San Francisco quake, more damage was done by fires than by the quake itself.

ADDITIONAL STEPS TO TAKE FOLLOWING AN EARTHQUAKE

Once you've survived the initial quake, your attention should turn to preventing any further injuries, fires, or other emergencies from occurring. You're going to be on your own for several hours or perhaps even for a day or two. With transportation and communication cut off it will be difficult to get help if anything happens. Here are the things you need to be thinking about:

1. Stop for a minute and try to adjust to the shock. Take a few deep breaths, assess the situation, and set some priorities on what needs doing. Try to stay as calm as possible and be optimistic. Put on a pair of heavy shoes, as you'll most likely be walking on a lot of debris. Refer to Section 3 for detailed information on surviving after a disaster.

2. Refrain from using any type of flame or electrical appliance that will cause a spark until you're positive there is no danger of a gas leak or starting a fire. Air out the building if there is any doubt about gas leaks.

3. Don't try to use the phone unless there is a life-threatening emergency. Not only will any phone lines still working be jammed with important calls, but it is highly unlikely that emergency personnel will be able to reach you with help for some time. Handle minor emergencies yourself.

4. Turn a transistor radio to the Emergency Broadcast Station in your area. Don't be surprised if there is not much immediate information forthcoming. Keep tuned to the radio for news as it does come in. You can also use a car radio (see Chapter 4).

5. Save the water in the toilet tank. Put a sign over the handle so it won't be flushed. Not only is it a good source of emergency water, but it should not be flushed if the sewer lines are broken.

6. Try to assess how badly damaged your house is. Any large earthquake will have strong aftershocks, and damaged structures may come down from these aftershocks. Look for broken beams, corners askew, leaning walls, or broken ceilings. Stay out of any structure about which you have doubts. Broken patches of plaster are normal and not a sign of trouble. Check for heavy objects that might be jarred loose in the aftershocks.

7. As tempting as it may be, don't go sightseeing. A large earthquake is enough excitement for anyone in one day. By moving around you may endanger not only yourself but others as well.

8. If you are in a coastal region, stay away from waterfront areas where there might be a tsunami (tidal wave). Stay tuned to the radio for information on tsunamis if you're close to the beach. (See the section in this chapter on tsunamis.)

HOW EARTHQUAKES ARE MEASURED

After an earthquake, one of the first pieces of information broadcast by the media is how strong the quake has been. This is always reported in terms of the Richter Scale, which is used to compare the magnitude of different quakes. An increase of 1.0 on the scale represents a tenfold increase in the size of the seismic wave, and an increase of 31.5 times the amount of energy released. Because of the logarithmic nature of the scale, the difference between just a couple of steps on the scale is enormous. For example, if a quake measuring 6.0 is compared to a quake with a magnitude of 4.0, the 6.0 quake has a seismic wave one hundred times larger, and releases almost one thousand times more energy.

Magnitude	Results
1.0 to 2.9	Probably won't be felt by most people. No damage.
3.0 to 3.9	Minor shaking, can barely be felt. No damage.
4.0 to 4.9	Tremors can be felt several miles away. Very minor damage may occur.
5.0 to 5.9	Fairly strong shaking —there's no doubt it's an earthquake. Some damage will be reported.
6.0 to 6.9	A "moderate" earthquake. Widespread damage and possible injuries or deaths will result.

7.0 to 7.75	A "major" earthquake in which most man-made structures will be damaged.
7.76 and above	A "great" earthquake. Damage and destruction are nearly total. Almost all man-made structures are severely damaged.

It gets a little complicated trying to predict the actual damage area. First of all, the epicenter of the quake is not a particularly good reference point from which to extrapolate possible damage. The heaviest destruction occurs along the fault line. Thus, buildings forty miles from the epicenter in one direction may sustain relatively minor damage, while buildings forty miles in another direction, on or near the fault line, may be hard hit. In addition, the intensity of a quake may vary somewhat from one local area to the next, depending on soil conditions.

TSUNAMIS

A tsunami (pronounced soo-na'-me) is a huge wave or series of waves caused by an earthquake. Even though it is commonly called a tidal wave it has nothing to do with tides. Coastal areas in Hawaii, Alaska, Washington, Oregon and California are the main places in the United States where tsunamis occur.

A tsunami may be fifty feet or more in height when it hits land, moving at a speed of about four hundred miles per hour. Strangely enough, a tsunami is hardly visible at sea, passing under ships with barely a ripple. It is only when it approaches shallow water near a coast that it rears to such terrific heights.

There is only one good way to deal with a tsunami—avoid it.

SIGNS OF AN APPROACHING TSUNAMI

People living in beach areas should be aware that if a strong earthquake has been reported in a coastal area or under the ocean, a tsunami may have been generated. Keep careful tabs of the situation by listening to the radio for warnings. Tsunamis may travel several thousand miles across an ocean before hitting land. At speeds of several hundred miles an hour, they can cross an ocean in just a few hours. This is not the time to go surfing or sightseeing. If there are warnings of an approaching tsunami you must evacuate.

The strength of the tsunami and the shape of the land determine how far inland the wave will go. You should move at least one mile away from the ocean and 150 feet above sea level. The further from the shoreline you can get, the safer you'll be. Tsunamis cause the most destruction in the first quarter- to half-mile inland. Tsunamis sometimes come in groups. The Alaskan earthquake in 1964, for example, generated a tsunami that struck Crescent City on the coast in northern California. In that case, it was the fourth big wave in a series that caused most of the destruction.

Some tsunamis may give a few moments warning: the ocean withdraws to far below the usual low-tide mark as the giant wave approaches. If you see this happening, run for the nearest high ground as quickly as possible.

A FEW FINAL WORDS ON EARTHQUAKES AND TSUNAMIS

In spite of the enormous power of both earthquakes and tsunamis, there is little to worry about if your are informed and prepared. Al-

though they caused a high loss of property over the years, relatively few people in the United States have been killed in either of these kinds of disasters. Stay calm, follow the suggestions in this chapter, and with any luck at all you'll have a great story to tell.

CHAPTER 12

The Unthinkable Disaster: Nuclear Accidents and Weapons

An alarm at four in the morning signaled the first hint of trouble. Technicians in the nuclear power plant's brightly-lit control room reacted swiftly but without panic. Similiar alarms had sounded before, usually indicating a minor malfunction. The technicians studied the control panels and manipulated buttons and levers to bring the reactor under control. This time their actions weren't sufficient. A complex chain of mechanical and human failures swiftly laid the foundation for a major nuclear accident. Within minutes the first leak of radioactive steam vented from the plant and began drifting over the darkened Pennsylvania countryside. Even at that point, no one inside the now-famous nuclear power plant at Three Mile Island realized the full seriousness of what was developing.

As the hours passed, a growing sense of concern gripped company officials. Top nuclear experts were called to the crippled plant to lend assistance, but even they were unable to halt the sporadic radiation leaks or bring the plant under

control. Further releases of radioactive steam and gas escaped from the plant and were detectable as far as twenty miles downwind. Attempts to cool the disabled reactor were complicated by a radioactive gas bubble that formed inside the reactor vessel.

The grave situation at the plant continued from one day to the next. Stores, banks, and schools in the surrounding communities closed as more than sixty thousand people left the area. The Governor of Pennsylvania advised pregnant women and young children to evacuate from a five mile radius around the plant. The greatest fear was that a total meltdown of the reactor core would breach the protective walls of the plant and send huge clouds of radioactive gas and steam spewing into the air.

Gradually, by a combination of technical expertise and good luck, the reactor was brought under control. However, the brush with catastrophe was too close for anyone to forget. The accident at Three Mile Island served as a very real reminder that we live in a nuclear age, with the potential for harmful radiation releases.

THE THREAT OF NUCLEAR ACCIDENTS AND WEAPONS

The prospect of a nuclear disaster, from whatever cause, has such a doomsday ring to it that some people are content to ignore the subject altogether. Yet it is realistic to consider soberly the threat of a nuclear disaster, how it might happen, and what could be done for protection. There are two principal ways in which a nuclear disaster might occur.

Nuclear Accidents The possibility of accidents involving nuclear material increases as

their use becomes more commonplace. The danger of future radiation leaks from nuclear power plants, however remote, is far from being the only hazard posed by nuclear materials. A number of accidents and close calls have occurred in the past few years. In 1978, for example, a Russian satellite carrying a nuclear reactor crashed in the Canadian wilderness. Fortunately, the radioactive debris caused no damage in this remote region, but it did serve to underscore the potential for nuclear accidents. Frequent shipments of highly radioactive substances by trucks, railroads, and airplanes also present a potential risk.

The results of a nuclear mishap can vary dramatically. If a container filled with radioactive materials is accidently broken, the danger may be confined to a relatively small area. On the other hand, in the worst possible nuclear accident, involving a full-scale meltdown of a nuclear power plant, large quantities of radioactive steam, gas, and debris could contaminate hundreds of square miles downwind of the plant. However, no matter what type of accident occurs with nuclear materials, it is not possible for containers of radioactive substances or even a nuclear reactor to explode like a nuclear bomb.

Nuclear Weapons The prospect of a nuclear war between the superpowers, however unlikely, is grim indeed. If this ever happens, probably the best you can hope for is to be on vacation in Australia at the time. The ever-growing spread of nuclear weapons adds to the danger of a possible nuclear exchange. Two decades ago, only a few of the major powers in the world possessed nuclear weapons. Today, an increasing number of smaller nations are joining the nuclear club. In addition, there is always the threat of a terrorist organization

either constructing or acquiring a nuclear bomb to use for their own ends. Although the growing spread of nuclear weapons is not comforting, it does change the dimensions of how they might be used. Instead of an all-out nuclear exchange, only a few relatively small bombs might be exploded. Regardless of the number and size of the bombs involved, people affected would need to know what to do to protect themselves.

RADIATION—A UNIQUE DANGER

The possibility of contamination from radiation is the characteristic that makes a nuclear disaster so unusual. Whether the emergency is caused by a nuclear accident or the explosion of a nuclear bomb, the unfamiliar threat of radiation must be recognized and protective measures taken. The danger is unique because radiation itself cannot be detected by human senses.

Nuclear substances are kept in special containers or behind heavy shielding. If radioactive matter loses its protective shielding in an accident, it presents a risk to people nearby. Certain nuclear emergencies create additional radiation problems. If a nuclear bomb explodes near the ground, it carries tons of pulverized material miles into the atmosphere. When these tiny grains of debris return to earth as fallout, they emit radiation. In this way the radiation from a bomb can spread over a large area.

The Effects Of Radiation Most researchers now maintain that exposure to any unnecessary radiation is best avoided, as even relatively small doses can trigger health problems years later. Delayed effects from radiation exposure manifest themselves as cancer, cataracts, genetic mutations, or sterility. Exposure to a large dose of radiation can quickly result in radiation sickness

or even death. The effects of radiation vary with the individual, but as a rule, infants and elderly people are the most susceptible.

Radiation Sickness The immediate signs of serious radiation sickness include nausea, frequent vomiting, headache, dizziness, diarrhea, and extreme fatigue. The symptoms last several days and unless hospital care is available, there is little you can do except comfort the victim. The person then usually makes a spontaneous and rapid recovery. Unfortunately, the worst is yet to come. Internal organs, blood, and marrow will have all been damaged, and within two to three weeks the initial symptoms reappear, often with greater severity, and the victim may die. Even if the victim recovers, he runs a higher-than-normal risk of other radiation-related diseases appearing years later. It is important to note that someone suffering from radiation sickness is in no way contagious; there is no danger in being near the victim. The only way you can get the disease yourself is by direct exposure to radiation.

How Radiation Is Measured Since radiation is impossible to detect with your natural senses, instruments must be used to gauge the danger. Equipment that measures radiation, such as a Geiger counter, would be used by rescue crews to estimate the degree of risk. The most common unit of measurement for radiation intensity is called the Roentgen. The chart below gives a rough idea of the short-term effects that can be expected from various doses of radiation.

0 to 50 Roentgens—No visible effects.

50 to 200 Roentgens—About half the victims will experience radiation sickness (nausea) on the first day after exposure; about 5% of the

victims will require medical attention. No deaths should occur.

200 to 450 Roentgens—This is a serious dose and most people will require medical attention. About half the victims will die within two to four weeks.

450 to 600 Roentgens—Serious radiation sickness will occur in all victims. Even with medical attention, more than half will die within one to three weeks.

Over 600 Roentgens—This is a severe dose that is nearly always fatal within two weeks.

PROTECTION FROM RADIATION

Whether a nuclear emergency stems from an accident or from the explosion of a bomb, there is always the hazard of radiation exposure. There are two principal ways to protect yourself: distance and shielding.

Distance In many cases, your best course of action is to evacuate the area as quickly as you can. Safety lies in putting as much distance as possible between you and the source of radiation. The authorities in charge will let you know when it is safe to return. All radioactive materials "decay" or lose their radioactivity with time. How quickly this occurs varies with the substance. As a general rule, the longer you can stay away from an area of known radioactive contamination, the safer it becomes. If you live near an installation that uses nuclear materials, give some thought to evacuation plans so you'll be prepared in case an accident ever occurs.

Shielding If it is not possible to leave the contaminated area, you can protect yourself by

blocking the radiation rays. This can be as simple as staying indoors for a day or two if the radiation exposure is very mild. Larger amounts of radiation will necessitate using heavy shielding materials such as dirt or bricks to stop the penetrating rays. Follow the advice of authorities, and if necessary use the information on protection from fallout given later in this chapter.

PROTECTION FROM NUCLEAR WEAPONS

The explosion of a nuclear bomb presents additional hazards and requires some special precautions. Even though the effects of a nuclear explosion are exceedingly powerful, it is possible to protect yourself. The consequences of a nuclear weapon vary, depending on a number of factors, including the size of the bomb, terrain, weather conditions, and whether the bomb is detonated in the air or on the ground.

Most bombs produce four main hazards. These occur in the following order: flash, heat, blast, and radiation (fallout).

1. *Flash*—When the bomb is detonated, an intense, bluish-white flash of light is generated. It is much brighter than the sun and can temporarily or even permanently blind anyone looking directly at it.

2. *Heat*—The initial flash is followed within a few seconds by a tremendous wave of heat that can set fire to flammable materials in its path. It can also burn people who are not under cover.

3. *Blast*—On the heels of the heat wave comes a powerful blast. This shock wave, with its terrific air pressure, damages or destroys many objects in its path.

4. *Radiation (Fallout)*—The tons of radioactive debris carried miles into the atmosphere in the familiar mushroom cloud eventually fall back to earth. In areas near the bomb blast, fallout may begin returning to earth within minutes of the explosion. It may be hours or even days later before regions further away receive any fallout. The fallout looks like grains of sand or table salt as it collects on the ground.

Protection From The Explosion

It is very possible you'll have at least some warning, should a nuclear explosion be imminent. Word would be flashed via radio and television, and in some communities, sirens would sound an alarm. A series of wavering sirens is the signal that protective action needs to be taken immediately.

If you are at home when you receive a warning, close all windows and doors to protect against the intense heat rays. If time permits, cover the windows with aluminum foil. Fill all available containers with water to use for fighting fires or to use in case the water supply becomes contaminated.

If your first warning of an explosion is the bright flash of light, take cover as rapidly as possible. Provided the explosion is several miles away, you will have approximately 5 to 15 seconds before the heat wave arrives and about 15 to 60 seconds before the blast hits. Seek protection immediately in a sturdy building, tunnel, ditch, culvert, or anywhere under shelter. If there is no time to find protection, curl up on the ground and cover your head. Once the initial effects of the bomb have passed, you must immediately begin planning how to protect yourself from the fallout that will follow.

Fallout

For those outside the area affected by heat and blast, the radiation from fallout presents the greatest danger. Some areas might get a large amount of fallout while others would receive little or none. Use the time before the fallout arrives to devise some type of protection.

Despite the danger of fallout, it does lose its potency fairly rapidly. The radiation emitted from the fallout particles is most powerful during the first twenty-four hours after the bomb explodes. Assuming no new fallout from other sources drops on the area, the radiation should decrease to roughly one percent of the original level within two days. By the end of two weeks it should be down to about one tenth of one percent of the original level. It's obvious, if you can't escape the fallout, that those first few days are good ones to spend under shelter. In fact, in some cases it may be necessary to stay under cover for as long as two weeks.

Shelter From Fallout

There are several different ways to seek shelter from fallout. None of them offer much in the way of comfort, but they may be the only ways to protect yourself. Each type of shelter uses the principle of putting as much heavy shielding as possible between you and the source of radiation. Common shielding materials, in their order of effectiveness, are bricks, sand, earth, and wood. Two feet of dirt, for example, should stop most radiation from reaching you. Care must also be taken not to inhale or ingest any of the fallout particles you might accidentally get on you. Be sure to take enough supplies into the shelter to last as long as you estimate it will be necessary to stay under cover. Use the evacuation list in Chapter 8 as your guide. A battery-powered radio is particularly important; it will

keep you apprised of official word on radiation levels.

Improvised Fallout Shelters Unless you have made advance preparations, your shelter will have to be improvised. Use an existing structure such as a basement, storm cellar, tunnel, mine shaft, cave, subway, or even the interior part of a large building. Wherever you find shelter, you must be sure that you are surrounded in all directions with as much shielding as possible.

If you are at home, a basement or storm cellar offers the best protection. You can improve the shelter by buttressing any areas that are not underground with sand bags, dirt, or other heavy material. Another option is to surround and cover a heavy table or workbench in the basement with shielding material such as bricks or sandbags. The space created inside can be used for protection.

A crawl space under a house that is set on foundation walls can also be used for shelter. Dig out an area in the crawl space which will at least allow you to sit up. Place shielding material between the ground level and the first floor of the house to create an enclosed area. On the part of the first floor which will be above you, place more dense material to form a protective roof on the shelter.

Make an outdoor shelter if it's not possible to construct one inside. Dig an L-shaped trench four feet deep and three feet wide and cover it with lumber or with doors which have been taken off their hinges. Then pile one to two feet of dirt or other shielding material on top. Use the shorter end of the L for an entrance; brace the walls and roof so they don't cave in.

Public Shelters Many buildings throughout the U.S. which are solid enough to offer fallout

protection have been designated as public fallout shelters. A standard sign of three yellow triangles inside a black circle identifies these buildings. In the early sixties, many such structures were stocked with food, water, and other supplies, and a trained shelter manager was in charge. Much of this planning has lapsed with time; at present many of these public shelters offer little more than protection from fallout. You may have to depend on what you bring with you if it's necessary to remain under shelter for a week or two. Check with your local emergency services office to see where the nearest public shelter is located and what plans have been made to accommodate the occupants in a time of emergency.

Home Fallout Shelter Whether you believe the construction of a home fallout shelter is worth the time, trouble, and sometimes considerable expense involved, depends on your judgment of the need for this type of protection. Such a shelter does offer one of the best methods of protecting yourself. The government has a variety of plans and designs for anyone interested in constructing a fallout shelter at home. These range from converting an existing room or basement to building a complete shelter. The best place to start is with the following free, 68-page booklet:

> "Protection in the Nuclear Age"
> Defense Civil Preparedness Agency
> 2800 Eastern Blvd. (Middle River)
> Baltimore, Maryland 21220

Relocation Providing adequate protection from nuclear weapons for millions of people is difficult. The government has recently been developing plans for massive evacuations of people in such high-risk zones as large cities or

the areas near important military installations. If an international crisis ever poses the serious risk of a nuclear exchange, people near likely nuclear targets would be moved to outlying rural areas. It's hard to imagine the evacuation of a large American city being anything but extremely difficult, but such action could protect you from at least the effects of a bomb's explosion and the immediate fallout.

Temporarily Leaving A Fallout Shelter

Since you want to minimize your exposure to any radiation, it's best to err on the side of caution and stay under cover as long as possible or until authorities give the all-clear signal. If you absolutely must leave a shelter in order to obtain, food, water, or other necessities, make your stay outside very brief. Ideally, when venturing into a fallout-contaminated area, you should wear protective clothing such as a raincoat and gloves. Discard your clothes before reentering a shelter, and if possible, take a shower to completely rid yourself of any particles of fallout. Clearly, these kinds of precautions may not always be feasible, but at least make every attempt to brush off any particles of fallout before coming back into the shelter.

Effects Of Fallout On Food And Water

Food that has been exposed to fallout is perfectly safe to eat provided that none of the fallout particles are actually swallowed. Any tightly-packaged foods or canned goods should be safe as long as the container is thoroughly washed or wiped off before opening. Water in covered containers is also safe to use. Wait for local authorities to declare the public water supply safe before using it. If you are forced to drink water from questionable sources, strain the water through a clean cloth or let it settle; after removing any solids, be sure to purify it.

CHAPTER 13

Blackout!

It had been a routine flight for the 727 jetliner. On the horizon the lights of New York glistened in the clear evening air as the pilot began to ease the plane in the direction of Kennedy Airport. Suddenly, the city disappeared. The pilot, much to his relief, was able to contact the control tower. On a battery-operated radio, the air traffic controller reported the incredible news that New York had lost all its electrical power. The plane was quickly diverted to an airport further to the south.

For the people in the darkened city it had been just another working day in November of 1965. Many were shopping or beginning the commute home from work. Without warning, at 5:17 p.m., the huge electrical grid supplying New York malfunctioned and all electrical power to the city abruptly stopped. Within minutes the problem spread and the rest of the eastern seaboard's electrical system followed New York's plunge into darkness, leaving an area of over eighty thousand square miles blacked out. Its lifeblood cut off, the East Coast megalopolis ground to a halt.

Millions of people simultaneously discovered the difficulties of being without electricity. All the buttons, switches, and levers that made things run were suddenly useless. Elevators

hung motionless between floors. Refrigerators, televisions, computers, stereos, and other vestiges of modern life were stilled.

Everyone waited expectantly for the power to return. Those with transistor radios listened to the announcers share their puzzlement. No one knew what had caused the blackout or when it would end. The telephone system, with its independent power supply, still worked, but the lines were jammed with an overload of calls.

Slowly people began working together to adjust to a world without electricity. Volunteers helped direct the snarled traffic. In hospitals, babies were delivered by candlelight and delicate operations were completed by battery lamps. A sense of adventure and fellowship took hold. Rescue workers searching for people in the subway tunnels found passengers, trapped inside railway cars, singing and telling stories in good-natured acceptance of their plight. A few people did take advantage of the situation: many cab drivers charged exorbitant fares, and some stores raised prices on flashlights and candles five or six times above normal. However, most people struggled through the long night of darkness with high spirits and good will.

Twelve hours after the blackout began, weary utility officials managed to restore most of the power. Even before all the electrical service was returned, investigations had begun to discover the cause of the blackout. Although this mammoth power failure was apparently a freak accident, no one has yet come up with a foolproof method of preventing large power grids from occasionally failing. In fact, several major blackouts have occurred since 1965, including another large one in New York City in 1977. The odds of future blackouts increase as electrical systems become more complex and energy supplies scarcer. But breakdowns in manmade electrical systems are not the only cause of blackouts.

A power failure frequently accompanies strong storms, floods, earthquakes, and other natural disasters. A blackout is one of the emergencies you are most likely to face.

HOW TO PREPARE FOR A POWER FAILURE

Sometimes there is a clear indication that a power failure is imminent, as when a strong storm is headed in your direction. In other circumstances there may be no advance warning. It's wise to have the necessary equipment on hand in the event of a power failure. Here's what to have:

1. *Emergency Lighting*—Keep a flashlight with fresh batteries in an easily accessible location. Consider having other forms of emergency lighting if needed (see Chapter 3).

2. *Radio*—Make sure you have a transistor radio with fresh batteries available (see Chapter 4).

3. *Cooking Equipment*—A camp stove or a barbecue can offer an alternative method of cooking in case of a power failure.

4. *Generator*—Some individuals may need a generator for standby electricity. A generator can power medical equipment, an expensive aquarium, or other electrical apparatus that should not be turned off. Generators are not practical for most homes because of their high cost.

Conserving Electricity To Prevent A Blackout

Utility companies are sometimes hard pressed to provide enough power to their customers. This most often happens on hot summer afternoons

when air conditioners are going full blast. During such "peak load" periods, utility companies may ask their customers to reduce the consumption of electricity to prevent the system from becoming so overloaded that a full-scale blackout develops. Power companies may also institute "rolling blackouts" by cutting the power for a few minutes at a time to certain areas on a rotating basis. If you are asked to temporarily reduce your use of electricity, remember that equipment that heats, cools, or produces light uses the most electricity. The following steps are suggested:

1. Turn your air conditioner to its lowest setting. Better yet, turn it off and use a fan.
2. Turn your refrigerator to its warmest setting.
3. Refrain from using electric lights, and substitute lower-wattage bulbs in your light fixtures when possible.
4. Refer to Chapter 15 for tips on how to handle hot and cold weather without electricity.

WHAT TO DO IN A BLACKOUT

Your first action if the power fails is to take stock of where you are and what needs to be done. There is no real danger in a blackout provided you are careful. Be especially watchful if it is dark; you don't want to stroll unintentionally out a window.

A Blackout At Home At home you should be equipped with at least a flashlight and a transistor radio. If only your house or apartment is affected, you may simply need to change a fuse or reset a circuit breaker. If this isn't the problem, notify the utility company that you are

without power, unless it's obvious that a large area is affected. Take the following actions if the blackout appears likely to last any length of time:

1. Open your refrigerator and freezer as infrequently as possible, to preserve the food inside. If the door remains shut, this food should last about two days. In hot weather, cover the refrigerator and freezer with blankets or other insulating materials.

2. Although the phone will still work, don't use it unless you have to make a truly urgent call.

3. *Turn off or unplug your electrical appliances* to avoid damage should there be a power surge when the electricity comes back on. Once the power has returned, give the system half an hour or so to stabilize before turning on electrical equipment.

4. If you do any cooking inside your home with a campstove, be sure to ventilate the room adequately. Don't use a barbecue inside.

5. If you need electricity for a true emergency, call the fire department for a generator.

A Blackout While Away From Home Probably your best course of action is to stay where you are if a blackout occurs while you are away. Resist the impulse to head for home, as travel will be difficult. Traffic lights and gas pumps won't work without electricity. If you're one of those unfortunate souls who happens to be in an elevator when the power fails, you must draw upon your patience. Press the alarm button periodically, even if you can't hear it; it may be ringing somewhere else. Yelling usually won't help unless you can hear rescuers.

DAMAGED ELECTRIC LINES

Broken or downed electric power lines accompany many blackouts. *Any* downed electric line should be regarded as if it were live and the line treated with extreme caution. Stay well away from it and do not touch any object with which the line is in contact. The electricity in a high-voltage line can injure or kill a person. A broken electric line often will spark as electricity jumps to nearby objects. Regardless of whether the damaged line appears live or not, it must not be touched.

Use the utmost caution in attempting to rescue anyone in contact with a live electric line. Do not touch the victim, as the electricity will be passed directly on to you. Before trying to move the victim or the wire, be sure you are standing on something dry such as a board or the rubber floor mat from a car. Use a dry board or stick to push the wire away and free the victim. Under no circumstances should you move the wire with any object that is wet or made of metal.

The victim is perfectly safe to touch once the power line is moved away. A severe electric shock can cause a person's heart and breathing to stop. If you are trained, administer CPR (cardiopulmonary resuscitation); otherwise, give mouth-to-mouth resuscitation (see Chapter 19).

SECTION 3

WHAT TO DO FOLLOWING A DISASTER

CHAPTER 14

Water—
The First Priority

Water is the single most important survival consideration in an emergency. Safe, potable water is a constant necessity. A person can survive days and perhaps even weeks without food, but even a day or two without water can be serious. When a disaster strikes, the condition in which it leaves the water system is an immediate concern. Heavy storms, earthquakes, and flooding can damage or disrupt the public water supply. Broken or flooded sewer lines may contaminate this supply. Even though the water is still running, it may not be safe to drink.

If the public water system is not functioning, or if it is contaminated, it will be up to you to find other sources of water until help arrives or the water system is repaired. This chapter will provide the necessary information on how much water you will need, where to get it, and how to purify it.

HOW MUCH WATER IS NEEDED?

As a general rule, one quart of water per person each day is a bare minimum. More would be better. A number of factors such as hot weather

or heavy work can dramatically increase the amount of water needed. Someone who is sick, especially with diarrhea and vomiting, may become dehydrated rapidly if lost liquids are not replaced. Symptoms such as these are often caused by consuming contaminated food and water. An injured person who has bled a lot will also need extra fluids.

Remember that this one-quart minimum per day is just enough for drinking. This does not include water for other activities such as cooking, brushing teeth, or washing hands. While these aren't absolute necessities, they can definitely make the world seem a brighter place.

How Water Gets Contaminated

The most common sources of water contamination are human and animal feces. In emergencies this contamination often occurs when broken or flooded sewer and septic tanks leak their contents into the water supply. The results may be serious. Contaminated water can play host to a variety of diseases, including dysentery, typhoid, infectious hepatitis, and cholera. Outbreaks of these diseases following disasters are always a possibility. Obviously an emergency situation is not an especially good time to come down with one of these illnesses. Even an intestinal upset from bad water can be not only debilitating but very awkward. It is simply prudent to be cautious of the drinking water if there is any reason to suspect contamination.

HOW TO PURIFY WATER

Keep in mind that dirt, rust, or other particles in the water do not necessarily make it unfit to drink. (An exception to this is fallout in the water —see Chapter 12). Before purifying the water,

strain out any sediment it contains. Pouring the water through several layers of clean cloth or paper towels will get out most of the grit. Letting the water settle for several hours will accomplish the same thing. Once any sediment in the water is removed there are a variety of sure and simple ways to purify it.

Boiling

This is the time-honored method and probably the best way to make sure water is safe. Bring the water to a rolling boil for at least five minutes. Boiling water will kill all bacteria, viruses, and parasites that may be lurking there waiting for a human body in which to grow. To improve the somewhat flat taste of boiled water, pour it back and forth between two containers several times to aerate it.

The drawback to boiling water is that some type of heat must be used. If gas or electrical supplies are not working there may be no practical way to boil water. If there is any danger of a gas leak, an open flame is out of the question.

Chlorination

You can chlorinate your own water by using most household liquid chlorine bleaches found in the supermarket, such as Clorox or Purex. Look on the label for the listing of 5.25% sodium hypochlorite as the active ingredient and use the following proportions.

Water	**Chlorine Bleach**
½ gallon	5 drops
1 gallon	10 drops

After adding the chlorine bleach, let the water stand for half an hour. It will then be safe to drink, although it will have a distinct chlorine taste. Letting the water stand uncovered for several hours will reduce the chlorine flavor as

the chlorine evaporates. This does not decrease the safety of the water unless it somehow becomes contaminated again.

Iodine

Ordinary household iodine used for cuts and scrapes can also be used to purify water. Add a 2% tincture of iodine solution to water in the following proportions:

Water	Iodine
½ gallon	10 drops
1 gallon	20 drops

Let the water stand for thirty minutes before using.

Water Purification Tablets

Iodine and halazone are the two types of water purification tablets commonly available. Either type is easy to use. Their small size makes them easy to store and they will keep for years. These tablets are also handy for purifying water while traveling or camping.

Iodine Tablets These small dark pills contain a substance with the formidable name of tetraglycine hydroperiodide, which releases iodine when put into water. Normally two tablets in a quart of water is enough to purify it. Check the directions on the bottle. Be forewarned that the water treated this way will not taste as if it came from a Rocky Mountain stream; the iodine taste it will have may not be altogether pleasing to the palate. Iodine tablets will keep for many years and kill a wide spectrum of organisms in the water.

Halazone Tablets These small white pills release chlorine into the water. Two pills per pint of water is recommended but check the

instructions on the label of the bottle. Halazone-treated water has a strong chlorine flavor.

Of the two kinds of purification tablets, the iodine type are preferred as they have a greater effectiveness against a wider range of organisms. There have been several studies indicating that there are no harmful side effects using either iodine or chlorine to purify water. Both types of purification tablets are available in sporting goods stores or pharmacies.

USING PURIFIED WATER

Be sure to use pure water for anything that might be ingested. It should be used for brushing teeth as well as for cooking. Purified water should also be used for cleansing wounds or injuries.

When water service is restored, the water is likely to have a strong chlorine taste as water officials take extra measures to be sure the water is not contaminated. It is perfectly safe to drink. Again, letting the water stand uncovered for several hours will lessen the chlorine flavor.

WHERE TO FIND WATER

First of all, forget about getting water out of a cactus plant or digging a solar still. Those are great projects for the Boy Scouts, but not very practical for meeting most emergencies. A variety of more useful methods are described below.

Your first step is to assess how much water is required. How many people will be needing water? How long a time will it be before outside help will bring more water? Are there circumstances that require more than normal amounts of water? Once an estimate is made of the amount needed, use the easiest and most acces-

sible source of water first. You may very well have a sufficient quantity of water on hand if there was enough warning prior to the emergency. If you have no water, don't despair. There are several places in the average home, apartment, or building where water can be found. All it takes is a little knowledge and a bit of ingenuity.

It is important to protect the good water that does exist. Do this by shutting off the water main coming into the building (see Chapter 5 for details). The water already in the pipes and tanks of a building will not be contaminated unless they have broken. Shutting off the water supply is necessary to keep this water pure. Once the water supply is shut off, it is simply a matter of retrieving the water in the system. The best places to find water are the toilet tank, the water heater, and the piping system.

Toilet Tank
Most toilet tanks contain from three to five gallons of good water. Merely lift the top off the back of the toilet and the water is ready to use. Hang a sign over the flushing lever as a reminder not to accidentally flush the tank water away. (If you suspect that the sewer system may be broken, the toilet should not be flushed anyway. See Chapter 16.) The tank water should not be used if the tank contains a chemical cleaner. The water will be colored (often blue) if a cleaner is being used. It probably doesn't need to be said, but don't use the water out of the toilet bowl.

Water Heater
Most home water heaters hold between thirty and fifty gallons of water. Water heaters are usually located in the garage, the basement, a closet, or the kitchen area. Apartment dwellers may or may not have their own water heaters.

Some apartments will have individual water heaters located in a closet or in the kitchen area. Other apartment houses will have one large, centrally located water heater that serves several apartments or perhaps the whole building.

To remove the water from a water heater, first be sure the water main to the house or building is off. Then turn off the water heater. Both electric and gas models normally have a knob on the side that should simply be turned to the off position. Near the bottom of the water heater there will be a spigot. It will usually have threads on it for attaching a hose. Open it by turning it counterclockwise. It may take a wrench or a few light taps with a hammer to get it open if it hasn't been used in a long time. The first water to come out may contain some sediment that naturally collects in the bottom of water heaters over time. Just because the water is a bit dirty doesn't mean it isn't good to drink.

The inside of a water heater is lined with glass and is similar to a giant thermos bottle. If there has been an earthquake or any other violent shaking of the water heater, this glass lining may have shattered; be watchful for fragments of glass in the water.

Pipes In A Building

The pipes that run throughout a building contain several gallons of water. To get at this water, first turn off the water main (see Chapter 5). Then make sure all the spigots in the building are shut tight. Find the highest spigot in the building, a shower on the second floor for example, and open it to let air into the system. Next find the lowest water tap in the building, usually a bathtub on the first floor, a garden hose connection outside, or a sink in the basement. Open this tap and gravity should force much of the water in the pipes to flow out of the

lowest spigot. This method works best in a two- or three-story house. It may work in a one-story building, depending on the difference in height between the highest and lowest taps.

Obtaining safe water from the pipes of an apartment building or an office can be done the same way. Just be sure the water to the building has been shut off so you aren't collecting contaminated water.

Other Sources Of Water

Most kitchens will have at least some drinks, or foods with a high water content that can provide needed fluids. Juice, soda pop, canned vegetables packed in water, and melted ice cubes are all good. Depending on the weather, rainwater or melted snow or ice may also provide water. Private underground wells may or may not be safe. When in doubt, purify. Swimming pool water, if purified, can also be used.

Where Not To Get Water

Radiator Water *Don't drink water from a car radiator.* The old story of someone stuck in the desert using the water from their radiator to survive is no longer possible. Almost all cars today can be expected to have at least some antifreeze in the cooling system. Unfortunately, antifreeze is poisonous. No matter how thirsty people get, they should not drink radiator coolant—it will hasten their demise.

Hot Water Boilers Many large buildings use hot water for heating. The water, heated in large boilers and then circulated in pipes and radiators, often contains chemicals to prevent corrosion, and these chemicals make the water undrinkable. Stay away from this source of water unless you're sure the water has not been treated.

CHAPTER 15

Protection From The Elements

With all the heated and air-conditioned cars and buildings we have today, it's easy to forget the powerful effects of weather on our bodies. Modern people are often strangers to the natural environment and an emergency may bring them into abrupt contact with the elements. If normal sources of heating and cooling are not available it will be necessary to find other methods to protect yourself against harsh weather. You also need to know how heat or cold can adversely affect the body and what to do if this happens.

SHELTER

By dressing wisely and using what shelter is afforded by most homes, you should be able to protect yourself against all but the worst Mother Nature can offer, even if you are without heating or cooling. In addition, your own home will be familiar and there are resources in it upon which you can draw. However, if a disaster threatens the safety of an area, don't hesitate to evacuate. You should avoid any building that has been structurally damaged, as in an earthquake. Nevertheless, a disaster is not the time to

start building a lean-to in the backyard. The Red Cross and other agencies set up emergency shelters in most disasters. Neighbors or relatives may be able to assist you as well.

It is vital in an emergency to assess the type of weather conditions that can be expected. If your clothing and/or the building you're in are inadequate, immediate steps need to be taken to improve your protection. Use what is handy and easy to get to. A trailer or recreational vehicle, or even a car, can all be used if a building is not available.

An emergency situation, by its very nature, is stressful. It is important to limit as much of this stress as possible. Understanding the dangers of hot and cold weather and knowing how to prepare for them will greatly reduce this drain on your stamina.

COLD

Cold weather emergency preparedness is essential in much of the U.S. Hard winters take their toll each year among those who are not ready to meet this challenge. In cold temperatures, large amounts of a person's reserve strength may have to be consumed rapidly to keep the body at its normal temperature. When a person's temperature starts falling, both physical and mental abilities are impaired. Making the right decisions and taking protective action become increasingly difficult. Inadequate shelter or clothing can bring on some of the ill effects of cold weather even in seemingly mild temperatures. Wet or windy weather can greatly aggravate the effects of cold. During winter, in cold climates, a "wind chill" factor is often figured into temperature readings. This takes into account the effects of wind on temperature and gives a more realistic picture of

how cold it truly is. Wind, even on a mild day, can drop the temperature to dangerously low levels. For example, a 15 mph wind at 40°F. will drop the temperature a person feels to a chilly 22°F. Clothes that are damp from perspiration or water lose their insulating abilities and add to the problem of cold weather. The effects of cold weather on the body can manifest themselves through hypothermia or frostbite.

HYPOTHERMIA

When the interior of the body starts to lose heat faster than it can produce it, a condition called hypothermia sets in. If this loss of heat continues, the temperature of the body core drops below normal, which reduces a person's dexterity and ability to think. Sometimes known as exposure, this condition can be deadly in a short period of time. The warning signs of hypothermia must be recognized and protective action taken immediately.

Warning Signs Of Hypothermia

Hypothermia often strikes when the temperature is a relatively warm 30° to 50°F. Wet, windy weather and poorly chosen clothes or shelter all hasten the speed with which it affects someone. The symptoms are subtle at first and can easily be missed or brushed aside. A person can be in serious trouble before the danger is recognized. As the temperature of the body core starts to fall a series of automatic responses begin. Common signs of hypothermia include:

- Intense shivering.
- Difficulty talking.
- Loss of coordination and memory.
- Pale skin.

If heat continues to drain out of the body and the internal temperature drops further, the victim loses the ability to shiver. Muscles begin to tighten and there may be occasional fits of violent shaking. The victim also loses the capacity to think or help himself. A person in this condition is in need of immediate help.

How To Treat Hypothermia

The best treatment is prevention. Learn to recognize the symptoms of hypothermia and the type of situation (cold, wet, windy weather) in which it may occur. Take the following steps to help someone suffering from hypothermia:

1. Take the victim to the best available shelter, preferably a warm, dry spot.
2. Remove wet clothing and bundle the victim in as many clothes, blankets, sleeping bags, etc. as you can.
3. Total skin-to-skin body contact is very effective for warming a victim. Set modesty aside and put the unclothed victim in a bed or sleeping bag with one or two other people.
4. If the victim is conscious, administer warm liquids to drink and quick-energy foods such as candy or sugar. Do not give alcoholic beverages.
5. Seek medical help.

FROSTBITE

Frostbite is the injury or destruction to body tissue caused by freezing. The fingers, toes, face, and ears are particularly vulnerable. Be alert for frostbite in very cold weather.

Symptoms
1. The affected skin area will turn abnormally light in color, often a grayish yellow. Blisters may appear.

2. Sometimes there is mild pain; sometimes the affected area may just feel numb and cold.

Treatment
1. Place the frostbitten area in warm water. The water should be just warmer than body temperature; 102 to 105°F. is best. Wrap the area in warm sheets and blankets if water is not convenient to use.

2. Be gentle with frostbite. Don't rub affected areas with snow or massage with your fingers.

3. Keep the victim as warm and dry as possible. Provide warm drinks; don't allow smoking or alcohol consumption as both restrict circulation.

4. Get medical help; frostbite can be serious and there is a danger of gangrene. Don't let the victim use the injured part until a doctor has seen it.

PROTECTION AGAINST THE COLD

Clothing
Your first protection is what you're wearing. When in doubt, take more than enough clothes with you as they can always be taken off. A disaster is no time to worry about looking stylish; wear what is practical to protect your body and conserve its energy. The following seven hints will help you keep warm.

1. A number of layers of clothing gives better protection against the cold than just one thick garment.

2. Stay dry. Wet clothing, besides being uncomfortable, loses much of its insulating ability.

3. Keep your face, ears, hands and feet warmly covered. They are the most susceptible to frostbite.

4. Remember the old adage, "When your feet get cold, put your hat on." The head can radiate large quantities of heat. A hat, especially a close-fitting woolen one, can cut this heat loss.

5. Wool provides effective protection against cold weather. It tends to shed water, and it still maintains some of its warming properties even if it gets wet. Cotton materials are not good protection against the cold and allow rapid loss of body heat if they get wet.

6. Duck- or goose-down jackets are lightweight and warm but are useless if they get wet. Fiberfill jackets, on the other hand, still maintain some of their warmth when wet.

7. Use a handwarmer. Large retail stores and some sporting goods stores sell inexpensive pocket warmers that will radiate heat for several hours.

In Your Home

There are a number of things you can do to make any building warmer and more comfortable even if heating is reduced or unavailable.

1. Dress warmly. It's ridiculous to shiver in short sleeves.

2. Keep moving to stay warm.

3. Close off as many rooms as possible. Heat only the room in which most of your activities are centered. Keep doors and curtains shut.
4. Use a fireplace if you have one. Keep in mind that most of the heat goes up the chimney. Make sure the flue is closed if the fireplace is not in use.
5. Be sure to ventilate properly when heating a room with any type of stove or heater that uses an open flame.
6. Eat or drink something hot before venturing out into the cold. It is also helpful to munch on candy, raisins, or other high-energy foods while working in the cold.

Preparing For The Cold

Getting ready for cold weather before it sets in can save a lot of shivering. Here are some basic steps to take:

1. Have plenty of extra clothing and bedding on hand; sleeping bags are particularly useful.
2. Stock up on fuels to heat your house such as coal, heating oil or wood.
3. Consider getting an emergency heater. Small, portable heaters that run on propane cylinders are sold at large retail stores. They furnish several hours of heat per cylinder and are a good source of short-term emergency heating.
4. Insulate and weather-strip your house.
5. Prepare your car for winter (with chains, antifreeze, etc.).

HEAT

Though the process is quite different, heat can be just as debilitating as cold weather. In an emergency where there is a power failure or a water shortage, the problems of heat are magnified. Too much heat can cause severe body reactions: heatstroke, heat exhaustion, or heat cramps. Heatstroke is the most serious; therefore it is important to identify it quickly.

HEATSTROKE

This is a medical emergency that is brought on when the body's natural cooling system ceases to function. It is usually caused by strenuous exercise in very high heat. Old age or an infirmity of some type can be a contributing factor. Heatstroke can come on very suddenly and the person may simply keel over. First aid must be started immediately to lower the body temperature or death may result.

Symptoms
1. Hot, red, dry skin.
2. No perspiration.
3. High body temperature—105°F. or higher.
4. Victim may be unconscious or convulsing.

Treatment
1. Cool the person with a cold bath, wet towels, ice packs, alcohol wipes, fanning, or any other way possible.
2. Do not give stimulants.
3. Get medical help immediately.

HEAT EXHAUSTION

This is often the result of long exposure to high heat and humidity, coupled with inadequate consumption of fluids. While not as serious as heatstroke, it should be treated immediately.

Symptoms
1. Cool, clammy, pale skin.
2. Near-normal body temperature.
3. Cramps, headache, nausea, dizziness, and fatigue may be present.

Treatment
1. Get the victim to a cool place out of the sun and have him lie down.
2. Cool the victim's body with wet cloths, fanning, or air conditioning.
3. Give the victim plenty of fluids and salt. Use a mixture of one teaspoon of salt to one glass of water if possible.

HEAT CRAMPS

High heat can cause cramping in the arms, legs, and stomach due to loss of both water and salt from the body. Administer salt water to the victim just as you would for heat exhaustion and massage the affected muscles.

PROTECTION AGAINST THE HEAT

Here's what to do to minimize the effects of hot weather:

1. Drink plenty of fluids. Ration your activities, not your water. Keep up your salt intake.
2. Stay out of the sun; work during the cool parts of the day.
3. Wear light clothing.
4. Keep drapes drawn and the lights off.
5. Stay in the lowest part of a building (the basement is best) as it will be the coolest.

A FEW FINAL WORDS ON PROTECTION FROM THE ELEMENTS

Heat and cold are powerful forces to be reckoned with. Pay attention to your body's signals; they are easy to ignore in the excitement of an emergency. Use the information in this chapter to help conserve your energy and protect yourself against the effects of the elements.

CHAPTER 16

Staying Healthy— Preventing Disease and Filling Your Stomach

An emergency is an especially poor time to come down with an illness. Medical facilities will be severely taxed and it may be difficult to get adequate treatment. Yet an emergency is precisely the time when there is the greatest danger of many health problems cropping up. Besides watching for possible injuries resulting from the disaster itself, you must guard against a number of specific diseases. Knowing what to expect and how to avoid problems is an integral part of taking care of yourself.

PREVENTING DISEASE

DISASTER DISEASES

There are a whole range of diseases that may surface in the wake of a disaster. While most are now normally rare in the U.S., they may make a sudden appearance in an emergency. Human feces is the source of many of these diseases. If

fecal matter is not properly disposed of or is allowed to contaminate food or water, it can cause a variety of serious diseases, including dysentery, typhoid, infectious hepatitis, and cholera. Health officials are always on the lookout for such diseases, but are especially watchful in a situation where water or sewer lines are disrupted.

To complicate matters, rodents and insects are attracted to garbage and waste, where they can multiply with amazing rapidity. They are often carriers of disease, and unsanitary conditions are their ideal breeding ground. Warm temperatures will increase the problem as insects are more active and things tend to spoil faster.

DISPOSING OF WASTE

The days of the outhouse have long been replaced by neat, efficient chrome and ceramic plumbing. But what happens if this modern system breaks down, as it well may in an emergency? Plans must be made, even if the plumbing will be out for just a few hours. If the sewer line is clogged or you can see it's broken, the plumbing system in your home must not be used. The same applies to damaged or stopped-up septic tanks. In addition, local authorities may ask you not to use plumbing fixtures if sewer systems have been disrupted.

If your plumbing doesn't work, here is what you can do:

1. Find another toilet that does work. See if neighbors or friends a short distance away have a sewer or septic system that is still functioning. Chemical toilets are another alternative. Many recreational vehicles, trailers, and construction sites have them.

2. If no toilet is available, make a temporary one. Any watertight container with a cover —such as a metal garbage can, a kitchen trash container, or a bucket—will work. Line the container with a plastic garbage bag to make both the disposal of the waste and the cleaning of the container easier. Pour a small amount of chlorine bleach or household disinfectant into the makeshift toilet each time it's used to keep down germs and odors. Keep the lid on the container when it is not in use.

3. Bury the contents of a temporary toilet if a dirt area is available. Waste should be buried at least a foot deep and 50 to 100 feet away from any inhabited building. If possible, dispose of the waste downhill from where you're located and away from any water. Make sure it is buried deep enough so insects and rodents can't get at it.

4. As a last resort, dig a simple straddle latrine. It should be roughly a foot wide, a foot deep and two or three feet long. Shovel some dirt into the hole each time it is used.

5. It may be that the water supply is knocked out but the sewer or septic system is still functioning. If you are without water pressure, it is still possible to flush any toilet. Fill a bucket or similar container with extra water not needed for drinking and pour this water into the toilet bowl. This will create enough water pressure to discharge the contents down the sewer.

ESSENTIAL HYGIENE

A few simple precautions can reduce your exposure to many of the health hazards present

following a disaster. A good way to remember how waste causes disease is to think of the four Fs—"Food, Fingers, Flies, and Feces". Much can be done to cut the risk of disease by disposing of waste correctly and maintaining as much cleanliness as possible. Here are some other things to keep in mind:

1. Purify water if there is any thought that it might not be safe to drink (see Chapter 14).

2. Keep all food and water covered. Don't eat any food that you suspect to be contaminated. Better to be a little hungry or thirsty than to risk contact with one of these diseases.

3. Stay as clean as possible. Even though it may be difficult to maintain normal standards of cleanliness, do the best you can. Not only is it healthier, but it will make you feel better. Be especially cautious when preparing food.

4. Try to avoid infection. Thoroughly wash and disinfect even minor cuts.

5. Keep insects controlled. Bury garbage, dead animals, or any material that might attract insects or rodents.

FILLING YOUR STOMACH

Food is a rather low-priority item when compared with other necessities following an emergency, in spite of how someone forced to miss a couple of meals may feel. In fact, the short-term results of hunger are more psychological than physical. The human body can sustain itself quite well for at least two weeks on the fuel it has stored. However, the psychological effects

on a person after even a day without food are important. Hungry people tend to be irritable and short-tempered, and may not make good decisions. Herein lies the great benefit of food.

WHERE TO FIND FOOD

Most homes will have at least some food available. If the electrical power is off, the food in refrigerators and freezers should be used first. Keep spoilage to a minimum by opening the doors on these appliances as infrequently as possible. Also, covering a refrigerator or freezer with blankets or any type of insulating material will preserve the food longer. Frozen food keeps two days or more before thawing out. The speed with which it thaws will depend on the size of the freezer, how full it is, and the temperature outside. Food that has thawed should not be refrozen.

Once anything that will quickly spoil has been eaten, use whatever stored emergency food you have. Then eat anything else that is left around the house. All canned goods are safe to eat as long as the can has not been broken and is not bulging at the end. If the utilities are out, there may be a problem finding a way to cook. A barbecue or camp stove is useful in these circumstances. Charcoal is safer to store than fuel for a camp stove. Use either a barbecue or camp stove outside or in a well-ventilated area. A fireplace or wood-burning stove are both other options for emergency cooking. Use thermoses to keep things warm once they have been heated.

What To Eat
Forget about dieting; eat as much as you need to keep your energy level up. High-energy snacks

and warm foods and drinks provide the most comfort. Foods such as candy, raisins, granola, or chocolate all give the body a quick energy boost.

Take care that any food eaten is safe. Keep in mind the adage, "When in doubt, throw it out." Spoiled or contaminated food can make a person very ill. Maintain as much cleanliness as possible when preparing food; wash hands and keep all cooking and eating utensils clean. Clean up and dispose of any garbage.

Special Foods

Many people, such as young children or the elderly, may require a special diet. Store a quantity of special foods before an emergency occurs if a need like this exists in your home.

A FEW FINAL WORDS ON STAYING HEALTHY

An awareness of the dangers of disease and the role human waste plays in causing illness allows you to take the precautions necessary to stay healthy in an emergency. In addition, by using the foods available to you wisely, you can keep up your good spirits. It is of prime importance to remain healthy in a disaster.

CHAPTER 17

Easing Your Mind

Remember all those Hollywood disaster films in which crowds of panic-stricken people are saved just in the nick of time by a strong-willed hero or heroine? This sort of scene may make a great movie but it rarely happens in real life. Most people are not heroes, but neither are they incapable of helping themselves. Anticipating and understanding emotional reactions to an emergency are crucial elements in coping successfully.

Anything that shakes up the daily routine of life is, to one degree or another, stressful. The anxiety experienced depends on the situation and an individual's reaction to it. It's common for most people to go through a definite series of emotional stages in an emergency. How pronounced these stages are depends on the graveness of the situation. In a simple blackout lasting a few hours, emotional reactions will be minimal. On the other hand, a hurricane that causes widespread destruction may sharply define these stages. Reactions tend to emerge in a predictable sequence that extends over several days or even weeks.

EMOTIONAL STAGES IN A DISASTER

Here's how reactions to a disaster normally take place:

Warning The majority of disasters have at least some warning period. The first word of an impending emergency is often met with a sense of optimism and perhaps even excitement. Many people will have a feeling of invulnerability, an "it can't happen to me" attitude. This fades as the emergency draws closer and a more serious appraisal of the danger is made. Still, group pressure and a desire not to appear overly concerned may continue to cause many people to be unrealistically complacent.

Impact Once the emergency is upon them, people turn all their thoughts to protecting themselves and to saving what they can. Mass panics in serious emergencies are not typical. Depending on the circumstances, individuals may be nervous or even frightened, but panic rarely occurs except when people believe that severe danger is imminent and all avenues of escape are blocked.

Shock Once the emergency has passed, the process of resuming normal life begins. Many victims will be in a state of shock. This is characterized by the victims' appearance: apathetic, dazed, and stunned. In a serious emergency, people may be disoriented and virtually incapacitated. They may not know what action to take and as a result they may do nothing. Some will perform a trivial task while ignoring a serious and compelling problem that demands immediate attention. This stage may last from several minutes to a number of hours depending

on the person and the situation. No matter how serious the circumstances, someone who has prepared for the disaster and knows what to do is more likely to begin taking positive action quickly.

Suggestibility Once the initial shock has worn off, most individuals' actions are dominated by suggestibility, extreme gratitude for even the smallest amount of help, and an urge to help others. They are grateful the damage wasn't worse, or, if the situation was extreme, they are grateful to be alive. There is an immediate and very strong concern for other family members and great emotional warmth among everyone in the community. People are still not functioning normally and there will be great confusion as they try to fulfill their needs to "help". The strong urge to be of assistance is often followed without much thought on the best way to be helpful. Rumors may abound at this point. This condition may last from a number of hours to several days.

Euphoria Clean-up and rebuilding operations are frequently marked by an atmosphere of strong altruism and good feelings toward neighbors and the community. Race, class, and status temporarily lose their importance as everyone pitches in with a spirit of brotherhood to get the community back on its feet. This outpouring of good will that binds the community together can last several days and perhaps even several weeks.

Ambivalence As time passes, the feelings of relief and good will that were so strong following the event begin to fade. Resentment or criticism of people and agencies connected with disaster relief efforts often surface. Bitterness at

losses experienced may be openly discussed. Symptoms of repressed emotional stress may appear in some people who had particularly trying experiences. Eventually life returns to normal as memories of the emergency fade.

HANDLING YOUR OWN REACTIONS IN AN EMERGENCY

There's a lot you can do to minimize the emotional impact of a disaster. Generally, being familiar with a problem and having at least some understanding of what action to take will help. An unknown situation or one in which a person feels helpless is the hardest to handle. Behavior is contagious and a calm, positive attitude will spread just as quickly as a fearful, negative one.

While there is no magic formula for handling your emotions at a time of stress, there are a number of steps you can take that will make a real difference. They include the following:

1. Be patient and positive. As hard as this may be at times, make a real conscious effort to impart your calmness and confidence to others. Remember, what can seem like a loss now may in the long run be beneficial. Your "can do" attitude will get things done.

2. Protect your body and conserve its energy, warmth, and resources. This is no time for spartan living if it can be helped. Fatigue can cause inattention, irritability, and loss of good judgment.

3. Recognize that whatever discomfort there is will pass. People are so conditioned to a life of great comfort that its loss, even temporarily, can be very upsetting.

4. Accept that it's okay to be afraid of the unknown and that these feelings are normal. Try to have a clear picture of what's going on. The faster the reality of the emergency is accepted, the sooner you'll be able to take constructive action.

5. Keep busy. Time will pass a lot more quickly during any waiting period if the mind is occupied. Get a game going, read, play cards, or do a simple task that will keep your mind active. This is also useful for children and others who may not have much to do and can use the distraction.

6. Concentrate on your immediate needs. Get the most out of each moment. Long-term problems will have long-term solutions that can be thought out another day.

STRESS IN A DISASTER

The stress of a serious emergency can alter a person's behavior. You can help ease these stress reactions if you're aware of what to look for and how to reduce them. These emotional disturbances are usually temporary but can be disabling while they last. An emotionally upset person can trigger these same reactions in others, making the situation even more difficult to handle. Typical reactions include the following:

Nervousness The person will have all the feelings typically associated with the "butterflies." He will feel nervous, shaky, and confused. Physical symptoms include slight nausea, pounding heart, restlessness, mild diarrhea, and frequent urination. This is a relatively

normal reaction in a stress situation and nothing to worry about.

Depression The person will seem dazed, depressed, and in shock. He may be very withdrawn and not able to respond to you. People in this condition may be unable to help themselves.

Hyperactivity The person will be overactive and will have a tremendous need to "do" something, no matter how useless. He may talk a mile a minute, make stupid jokes, brag, make constant and conflicting suggestions on what needs to be done, or flit from one task to another without apparent purpose. A person in this state can cause general confusion, slowing down important activities and making decisions difficult to reach.

How To Help

It is to your benefit as well as the victim's to help him function constructively. Maintaining a stable and supportive emotional climate is important. In addition, a shower, warm food, clean clothes, and rest can do wonders for a distraught person. People will react better if they know what is going on, have a purpose, are organized, and don't feel isolated.

Effects On Those Lending Assistance

In any major emergency, many people from outside the affected area become involved in helping the disaster victims. These people, whether they be professionals who are serving as part of their job or simply volunteers from the next town, can also expect to be affected by the disaster. This is typically manifested by a tremendous output of rather low-efficiency work. There may be a great deal of rushing about without any purpose or design. The sheer magnitude

of what has happened may bring on an urge to fix it all at once. Although the work done is usually valuable, it is often performed sloppily and without much forethought. Harm may even be caused to injured people in the rush to "help" them. Again, people who are prepared are less likely to waste their efforts.

SECTION 4

FIRST AID IN A DISASTER

CHAPTER 18

Preparing a First Aid Kit

It is clearly advantageous, whether a disaster occurs or not, to have a kit of basic medical supplies in your home. It will undoubtedly come in handy even if minor cuts and scrapes are the worst emergencies you ever encounter. Many people already have the beginnings of such a kit in their medicine cabinets. A practical first aid kit can be relatively simple—you don't need to be prepared for major surgery or have the equivalent of a hospital dispensary in your hall closet. In fact, you can probably equip your home by merely organizing what you have and purchasing a few additional supplies.

There are two ways to acquire a first aid kit. The easiest method is to go to any large retail store or drugstore and purchase a commercially-prepared kit. The problem with buying such a kit is that it usually won't contain exactly what you want. With a little more effort you can assemble a customized first aid kit designed for your own particular requirements. This can usually be accomplished less expensively than buying a commercial kit, and you'll be able to select the items you really want. This chapter outlines what to include in a first aid kit for your home and car. The emphasis is on practical,

inexpensive materials aimed at meeting most common medical emergencies. These materials can be purchased at most drugstores or pharmacies.

A tackle or tool box makes an excellent container in which to keep a first aid kit, as it allows you to find an item quickly when needed. Clearly label your first aid kit and list its contents inside for easy reference. Everyone in the household should be familiar with the kit's contents and know where it is kept. Store it out of reach of small children.

HOME FIRST AID KIT

ESSENTIAL ITEMS

Bandaging Materials
Ace elastic bandage

Adhesive tape—One roll, one inch wide.

Bandaids—One box.

Gauze bandage—One roll, four inches by five yards; one roll, two inches by five yards.

Gauze pads—One box of sterile pads, four inches square.

Tourniquet—A short, strong stick (such as a one inch dowel, eight inches long) and a piece of clean cloth, two inches wide and two feet long.

Triangular bandage—One triangular bandage, either commercially available or homemade. (To make one, cut a triangular piece of clean sheet 36 inches on each of three sides.)

Medicines
Antibacterial cream—One tube of an antibacterial cream such as Neosporin ointment.

Antiseptic solution—One bottle of an antiseptic such as Betadine solution.

Aspirin—One bottle.

Prescription drugs—Keep a supply of any prescription drugs which are required by someone in the household on a regular basis. Be sure to rotate them to keep the supply fresh.

Miscellaneous

Cotton-tipped swabs—One box.

First aid book—This is the most important item in your first aid kit (see Appendix 1).

Matches

Paper and pencil

Safety pins

Scissors

Thermometer

Water purification tablets—Either halazone or iodine tablets.

OPTIONAL ITEMS

Medicines

Calamine lotion—For soothing itches and rashes.

Oil of cloves—For toothaches.

Petroleum jelly—For chafed or chapped skin.

Prescription drugs—You may wish to ask your doctor for a small supply of both a broad spectrum antibiotic and a general painkiller. Your doctor should give you clear instructions on their use. Self-medication is dangerous and a doctor should always be consulted if at all possible.

Salt tablets—For use in hot weather.

Soda—One box of baking soda for stomach upset.

Miscellaneous

Eye dropper

Instant cold pack—For sprains, bruises, and to prevent swelling. When an inner pouch is squeezed and broken a chemical is released that turns the packet icy cold.

Magnifying glass—For inspecting cuts, splinters, and objects in the eye. A small one can be purchased inexpensively.

Penlight flashlight—The best type of flashlight for examining ears, nose, or throat.

Snakebite kit—For people who live in an area frequented by poisonous snakes. When you buy the kit, read the instructions carefully so you'll know how to use it.

CAR FIRST AID KIT

A first aid kit for your car is also important. If you are in your car when a disaster strikes, need to travel in an emergency, or have an accident, you'll be equipped to render first aid. The items in this kit are geared towards bandaging and stopping bleeding, which are the most likely types of first aid situations you'll encounter. A small tackle box or lunch box makes a good container for the first aid kit in your car. In addition to the first aid items listed here, refer to Chapter 8 for other emergency equipment to consider for a car.

Bandaging Materials

Adhesive tape—One roll, one inch wide.

Bandaids—One box.

Cloth compresses—Two clean cloth compresses, three feet square. They can be cut from a sheet and stored in a plastic bag to keep them clean.

Gauze bandages—One roll, four inches by five yards.

Gauze pads—One box of sterile pads, four inches square.

Tourniquet—A short, strong stick (such as a one inch dowel, eight inches long) and a piece of clean cloth, two inches wide and two feet long.

Triangular bandage—One triangular bandage, either commercially available or homemade (a triangular piece of clean sheet, 36 inches on each side).

Miscellaneous

Coins—For a phone call.

First aid book—The most important item to carry. For convenience, a small, pocket-sized first aid book is useful (see Appendix 1).

Glasses—An old pair of prescription glasses if you need them in order to drive.

Pencil and paper

Safety pins

Scissors or a pocketknife

CHAPTER 19

Quick Reference Guide to First Aid

Sooner or later nearly everyone is called upon to perform some type of first aid. First aid skills are particularly valuable in an emergency, as it is very possible that immediate medical care may be difficult to obtain. Furthermore, if large numbers of people require medical attention, hospitals and emergency personnel will be unable to treat everyone simultaneously.

However, good first aid entails understanding the limits of what you should try to do. Well-meaning first aiders sometimes end up actually harming the victim by overstepping their training. Your job is to maintain life support and provide what emergency care you can until medical help arrives. The information in the following pages is designed to provide you with the basics needed to cope with first aid situations that may be encountered in a disaster. It's worth noting that both first aid training and a first aid manual will improve your ability to respond to an emergency. (See Appendix 1 for information on books and classes.)

FIRST AID

CHECKING THE VICTIM

Before beginning specific first aid, you must assess the situation and determine what needs to be done. *The two most important first aid priorities are to make sure the victim is breathing and to control serious bleeding.* When you come upon a victim, here's what to do:

1. Is the victim conscious? Tap the person gently on the shoulder and ask loudly, "Are you all right?" People sometimes fall asleep in strange places and you don't want to start artificial respiration on someone who is just taking a nap.
2. If the victim is unconscious check for:

 A. *Breathing*—Put your hand on the victim's abdomen and your ear over his mouth.

 Look to see if the chest is rising and falling.

 Listen for sounds of breathing.

 Feel the stomach and chest for movement.

 Begin artificial respiration if no breathing is detected. (See page 197.)

 B. *Bleeding*—Serious bleeding must be controlled immediately. (See page 200.)

Next, try to determine what caused the injury or illness. Take the following steps to care for a victim until medical help arrives:

1. Make sure that help is on the way; don't assume someone else has called.

2. Loosen tight clothing and look for hidden injuries.
3. Note the victim's skin color and pulse rate. The best place to check for a pulse is at the carotid artery in the throat. Place the tips of your index and middle fingers on the victim's Adam's apple. Then slide your fingers into the crease between the windpipe and the muscles of the neck and you will feel a pulse. A normal pulse rate is about 72 beats per minute.
4. Observe if the victim is coherent. If so, what can he tell you about his condition?

FIG. 10 PALPATION OF THE CAROTID PULSE

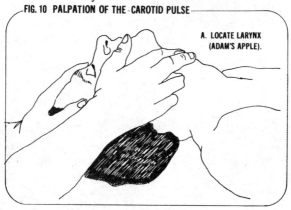

A. LOCATE LARYNX (ADAM'S APPLE).

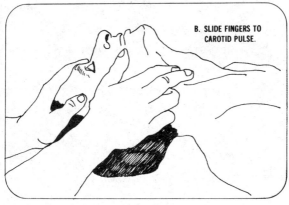

B. SLIDE FINGERS TO CAROTID PULSE.

Illustration from *Cardiopulmonary Resuscitation*, copyright © 1974 by the American National Red Cross, reproduced with permission.

5. Check for medical identification tags.
6. Keep the victim quiet to avoid any further injury. Move the victim only if it's necessary to get him to an area of greater safety. It is best not to move someone with suspected neck or back injuries.
7. Treat the victim for shock.
8. Reassure and comfort the victim.

ARTIFICIAL RESPIRATION

Once a person has stopped breathing, only four to six minutes can elapse before loss of oxygen causes permanent brain damage or death. If the victim is not breathing, start artificial respiration immediately, using the mouth-to-mouth resuscitation method.

Mouth-To-Mouth Resuscitation
1. Place the victim flat on his back and kneel beside him near his head.
2. Tilt the head back and arch the neck by placing one hand under the victim's neck and lifting while gently pressing with the other hand on the victim's forehead. This opens the airway, and is sometimes enough to start a victim breathing again on his own.
3. Place the palm of your hand on the victim's forehead, and pinch his nose shut with your thumb and forefinger.
4. Check to see that the victim's mouth is clear of obstructions. Remove dentures.
5. Place your mouth over the victim's mouth, forming an airtight seal.
6. Begin by blowing in four quick breaths. Then give a breath at a steady rate of once every five seconds.

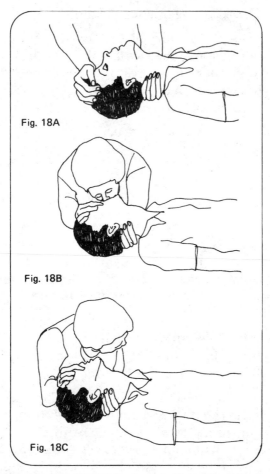

Illustration from *First Aid for Foreign Body Obstruction of the Airway*, copyright © 1976 by the American National Red Cross, reproduced with permission.

7. Turn your head to the side after giving each breath and listen for the exhalation of air from the victim's lungs. You should also be able to see the chest rising and falling.

8. For small children or infants, cover both the mouth and nose with your mouth and blow puffs of air into the lungs every three seconds. *Serious damage may result from blowing too hard into a child's lungs.* Don't arch the neck as much as with an adult.

Clearing A Blocked Airway

If you cannot get an exchange of air, the airway is blocked. It must be cleared.

1. Recheck the position of the victim's head; make sure the neck is sufficiently arched to allow a clear passage of air.

2. Look to see if there is any foreign body in the mouth or throat blocking the flow of air. If there is, remove it with your fingers or turn the victim on his side and knock it loose with sharp blows between the shoulder blades with the heel of your hand.

3. If the airway remains blocked, a rapid thrust to the upper abdomen can force enough air from the lungs to expel the blockage. Here's how to do it:

 A. *If the victim is standing or sitting*—Stand behind the victim and wrap your arms around his waist. Put the thumb-side of your fist against the victim's abdomen. Position your fist just above the navel and below the rib cage. Put your other hand on top of your fist and press into the victim's abdomen with a quick upward thrust. Repeat the thrust if necessary.

 B. *If the victim is lying on his back*—Kneel by the victim's side and place the heel of one of your hands on the victim's abdomen. Position your hand above the navel but below the rib cage. Put your other hand on top of this hand and push with a quick upward thrust toward the chest. Repeat the thrust if necessary.

Continue to give artificial respiration until qualified medical help arrives, the victim recov-

ers, or you are too exhausted to continue. If the victim begins breathing on his own, he still must see a doctor. Never leave a recovered victim alone; he may stop breathing again.

BLEEDING

Bleeding must be stopped immediately; a loss of even a quart of blood is extremely serious. The heart circulates blood out through the arteries and back through the veins. A severed artery spurts bright, red blood; this is the most serious type of wound, as blood is rapidly pumped out of the body. Blood from a cut vein is darker in color and flows steadily. Use the following four steps to stop bleeding:

1. *Direct Pressure*—Put pressure directly on the area that is bleeding. Use a clean cloth, a piece of clothing, or whatever is available. If nothing else, use your hand.

2. *Elevation*—If the wound is on an arm or leg, elevate the limb so it is higher than the heart. However, *don't move a limb if you suspect a broken bone.*

3. *Pressure Point*—If bleeding continues, use a pressure point while continuing direct pressure and elevation. There are a number of places on the body where an artery is close enough to the skin's surface so that pressing on it will stop the flow of blood. The two best pressure points to use to stop bleeding are the brachial artery and the femoral artery. Here's how to find them:

 Brachial Artery—Use the brachial artery to stop bleeding on an arm. The brachial artery is located on the inside of the arm

Reference Guide to First Aid 201

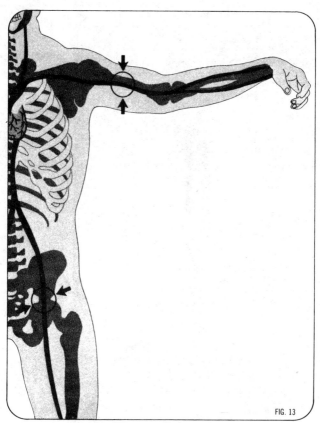

FIG. 13

Pressure Points

Illustrations from *Advanced First Aid and Emergency Care*, copyright © 1973, 1979 by the American National Red Cross, reproduced with permission.

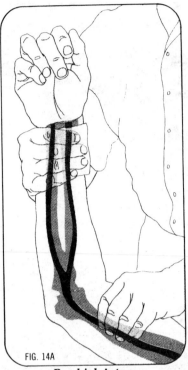
Brachial Artery

Femoral Artery

halfway between the shoulder and the elbow. Press on the inside of the arm between the two muscle groups towards the bone with the flat surface of your fingers.

Femoral Artery—Use the femoral artery to stop bleeding on the leg. The femoral

artery is located on both sides of the groin. With the victim on his back, press with the heel of your hand slightly below the middle of the crease in the groin between the thigh and the abdomen. Keep your arm straight to get enough pressure.

4. *Tourniquet—A tourniquet should only be used when absolutely nothing else will stop the bleeding.* Because a tourniquet completely cuts off the supply of blood, it must be assumed that the part of the limb below the tourniquet will have to be amputated. To apply a tourniquet:

 A. Wrap a wide (two-inch) piece of cloth twice around the limb just above the wound.

 B. Tie a knot and place a short stick on top of it. Tie two more knots over the stick.

 C. Turn the stick until bleeding stops. Tie the stick down with another strip of cloth.

 D. Once a tourniquet is on, leave it on. A doctor is the only one who should loosen it. Leave the tourniquet clearly visible. Attach a note to the victim, stating the location of the tourniquet and the time of application.

 E. Treat for shock.

BROKEN BONES

A broken or cracked bone is called a fracture. There are two common types: simple and compound. A simple fracture is a broken bone that does not cause an open wound on the skin's surface. The more serious compound fracture does involve an open wound, through which the bone may protrude.

Symptoms

Look for the following signs if you suspect a broken bone:

1. Deformities and differences in shape or length with corresponding bones.

2. Swelling and discoloration over the affected area.

3. Pain or tenderness when the suspected fracture site is touched.

Treatment

1. Call for medical help.

2. Don't move the broken bone unless it's necessary to transport the victim to a place of greater safety.

3. Stop any bleeding associated with the suspected break. If the skin is broken, simply cover the wound with a clean dressing. Don't try to disinfect or clean the wound. Applying an ice pack to a simple fracture helps reduce pain and swelling.

4. Treat for shock.

Splinting A Fracture A suspected fracture should only be splinted if there will be a delay in obtaining an ambulance or other medical help. A splint immobilizes the broken bone, decreasing the pain and the possibility of further injury. Construct a makeshift splint from two boards or other rigid materials of appropriate length. Rolled up magazines or newspapers make good splints if boards are not readily available. The splint must be long enough to extend above and below the injured area and nearest joint. For example, if the break is in the lower leg, immobilize both the knee and ankle joints with a

splint. Splints are more comfortable and fit better if some type of padding material is put between the splint and the injured limb. Place one board on each side of the arm or leg. Tie the boards firmly together with pieces of rope, cloth, etc. If you are unable to find splinting materials, strap a broken leg to the other one or a broken arm to the chest to help immobilize the broken bone.

BURNS

Burns fall into three categories according to their seriousness.

First-Degree Burn A first-degree burn involves minor damage to the surface of the skin. Symptoms include pain, mild swelling, and redness. Treat by immersing the burn immediately in cold water to relieve the pain. Cover with a dry, sterile bandage if necessary. Medical treatment is not required unless the burn extends over a large area of skin.

Second-Degree Burn A second-degree burn damages several layers of skin and forms blisters. It is accompanied by considerable swelling and pain. To treat, submerge the burn immediately in cold water until the initial pain is reduced. Gently dry the burned area and cover with a sterile dressing. Keep blisters intact for as long as possible. Don't use any kind of ointment or cream on the burn; absorbent cotton must not be used as it will stick to the burn. Seek medical help if the burn is serious or becomes infected.

Third-Degree Burn A third-degree burn completely destroys all the layers of skin. The burn area appears white or charred. Pain may actually be less than that of a second-degree

burn because the nerve endings in the skin are destroyed. *A person with a third-degree burn must have medical help.* Do not remove pieces of clothing or anything else that may be sticking to the wound. Simply cover the burned area with a sterile dressing and seek medical help. As with a second-degree burn, don't use ointments or creams and don't bandage with absorbent cotton. If a burn victim can't be seen by medical personnel within an hour, have him sip a solution of one teaspoon salt and one-half teaspoon baking soda mixed in a quart of lukewarm water. Don't give liquids to an unconscious or nauseated person. Treat the victim for shock.

Chemical Burns Treat a chemical burn by immediately using large quantities of water to flush away the corrosive agent. Continue to wash the area for several minutes. Seek medical attention if the chemical burn is serious or covers a large area.

CUTS AND INFECTIONS

Whenever a break in the skin occurs, the bleeding must be stopped and the wound made free from infection. Leave the cleaning of a severe cut or a fracture wound to a doctor. Treat a surface wound that is not bleeding badly in the following manner:

1. Wash the cut thoroughly with warm soap and water.
2. Apply a disinfectant solution.
3. Bandage with a sterile dressing.
4. Change the bandage when needed. Apply an antibacterial cream with each new dressing.

Infection Dirt or bacteria in a wound cause it to become infected. Signs that a cut is infected include redness, swelling and increased tenderness. If the infection worsens, the victim will run a fever and red streaks will spread away from the wound. If this occurs, see a doctor immediately.

HEART ATTACK

Heart disease is the number one cause of death in the U.S. Not only are heart attacks a common medical emergency, but the stress of a disaster may heighten the possibility of a susceptible person having an attack. The first hour or two of a heart attack presents the greatest danger to the victim. Therefore, it is crucial to recognize the early warning signs. The symptoms of a heart attack often mimic other, minor problems such as indigestion or heartburn. If a heart attack is suspected, don't delay getting the victim to a hospital for proper diagnosis.

Symptoms
1. There is usually a steady, crushing pain or pressure in the center of the chest. The pain may radiate out into the neck, shoulders, and arms.

2. The face and skin may be very pale, with a bluish tinge at the lips.

3. Nausea, weakness, sweating, and shortness of breath are frequently present.

Treatment
1. Call for medical assistance immediately.

2. Make the victim comfortable and keep him covered with a light blanket. Maintain normal body temperature.

3. See if the victim has medication to take for this problem, such as nitroglycerin tablets.

4. If breathing and heartbeat stop, the victim must immediately be given cardiopulmonary resuscitation (CPR). Artificial respiration will not help if the victim's heart has stopped beating. CPR, a combination of mouth-to-mouth resuscitation and external heart massage, must be learned in a class. It should only be attempted by a qualified person (see Appendix 1 on how to get trained).

SHOCK

Shock frequently accompanies an injury or sudden illness. It is a physical reaction which has nothing to do with other types of shock such as electric shock or insulin shock. Instead, it is a general depression of vital body functions, especially when there has been a loss of blood or lack of oxygen. Shock can be life-threatening even when the conditions that caused it are not. Treat a victim for shock in all but minor first aid situations.

Symptoms
1. Pale, cold, clammy skin.
2. General weakness.
3. Rapid, irregular breathing.
4. Rapid, weak pulse of over 100 beats per minute.
5. In severe shock, the pupils of the eye are greatly dilated.

Treatment

1. Provide life support for the victim. Give artificial respiration if necessary and stop any bleeding.
2. Keep the victim lying down and comfortable. Cover him with a blanket to avoid getting chilled. However, do not make the victim too warm. The object is to maintain body temperature.
3. Elevate the feet slightly.
4. Place the victim on his side if he is unconscious, so that he doesn't choke if vomiting occurs.
5. If you suspect injuries of the neck or back, do not move the victim at all.
6. If help will be more than an hour in arriving, give the victim sips from one quart of lukewarm water mixed with one teaspoon of salt and one-half teaspoon of baking soda. Don't give liquids if the victim is nauseated, unconscious, or has abdominal injuries.

Upset Stomach

Consuming contaminated food or water, as may accidentally happen in an emergency, can result in stomach upset and diarrhea. Try to replace the lost body fluids with weak tea, soft drinks, or other liquids. Consult a doctor if the symptoms persist or if there is an accompanying fever.

A FEW FINAL WORDS ON FIRST AID

Perhaps the most important idea to keep in mind when giving first aid is not to cause any further harm to the victim. Your basic goals should be:

1. Provide life support.
2. Keep the victim comfortable and don't move him unless absolutely necessary.
3. Call for help.

Let me emphasize again that both first aid training and a first aid manual will improve your ability to respond in an emergency. (See Appendix 1 for information on books and classes.)

APPENDICES

APPENDIX 1

Resources

Your reaction in an emergency is only as good as your knowledge of what to do. Accurate, easily accessible information is priceless. It can relieve needless worry and allow you to take the right actions confidently. Even the most carefully trained individual can benefit from having resources to fall back on when needed. The following is a review of the best resources in first aid, medical self-help, and disaster preparedness.

FIRST AID

A good first aid manual is the most valuable book you can purchase. It will equip you with the knowledge necessary to help the victim of a sudden illness or accident. Taking a first aid course will make your manual even more useful. Emergency methods are constantly being updated and improved, so if you haven't had any first aid training in a while, it's time for a refresher course. The classes listed below can often be arranged through your place of work, a school, club, or community group.

FIRST AID BOOKS

Advanced First Aid and Emergency Care, prepared by the American National Red Cross; published by Doubleday and Co., 1973; paperback, 318 pages. This book is comprehensive, easy to understand, well-illustrated, and covers every type of first aid emergency likely to be encountered. While there are other good first aid books sold, this one is the most complete for the layperson. It is designed to accompany the Red Cross First Aid class by the same title. However, whether you take the course or not, the book will substantially improve your ability to provide assistance in an emergency. This manual is available through most bookstores or the Red Cross office in your community.

Hip Pocket Emergency/Survival Handbook, by Robert E. Brown; published by the American Outdoor Safety League, 1979; paperback, 45 pages. This informative four-by-five-inch booklet is designed to help you overcome the unexpected emergency. Its compactness makes it an excellent first aid guide to carry in the car or on a trip. The booklet deals with thirty common emergencies, which are listed on the cover for easy reference. It contains a reflective mylar centerfold which can be used for signaling, and the cover is impregnated with wax to function as a fire starter.

A Sigh of Relief—The First Aid Handbook for Childhood Emergencies, produced by Martin I. Green; published by Bantam Books, 1977; paperback, 199 pages. This is the best first aid and safety book for childhood emergencies. The book features a reference system that makes it very easy to locate needed information. *A Sigh of Relief* is an excellent first aid reference book for parents, teachers, and others who work with children.

FIRST AID CLASSES

Standard First Aid (Multi-Media System) — The Multi-Media System is an introductory class that covers the basics of first aid. The topics include such things as artificial respiration, burns, poisoning, shock, and wounds. The class serves as a good place to start your first aid training or as a refresher course to update your skills. This eight-hour class is taught in one day or in four sessions, each two hours in length. Call your local Red Cross office to find out when the next class is to be offered.

Standard First Aid Class — This sixteen-hour lecture class offers a more in-depth approach to basic first aid than the Multi-Media System course. It is frequently offered through local adult schools or community colleges. Call your Red Cross office for more information.

Advanced First Aid and Emergency Care — This is the most complete first aid class available for the layperson. It trains you to become highly proficient in all areas of first aid and familiarizes you with basic paramedic skills. No previous first aid training is required. The class is taught through many community colleges as a regular course or from your local Red Cross office. It is forty hours in length.

Cardiopulmonary Resuscitation (CPR) — Cardiopulmonary resuscitation, a combination of artificial respiration and external heart massage, can save heart attack victims by keeping them alive until emergency personnel arrive. CPR is also used for victims of drowning, electrical shock, and other cases where breathing and heartbeat have stopped. The eight hours it takes to get this training could save a life. CPR cannot be learned from a book; the technique must be taught in a class sanctioned by the Red Cross or the American Heart Association. Both of these organiza-

tions offer training sessions in most communities.

MEDICAL SELF-HELP

A variety of health problems can arise in an emergency and may be complicated by a temporary breakdown in communication and transportation. Therefore, some basic medical self-help resources are desirable. They are useful in a disaster and will also enable you to take a more active role in your own everyday health care.

A Dictionary of Symptoms, by Dr. Joan Gomez; published by Stein and Day, 1977; paperback, 398 pages. There are a number of home medical guides which explain most health problems for the layperson, although this one is outstanding for its conciseness and clarity. A book such as this improves your ability to assess a health condition and to respond effectively to the problem. It can also help you know when to call a doctor and what types of questions to ask.

The Merck Manual of Diagnosis and Therapy (13th Edition), by Robert Berkow, M.D., Editor; published by Merck and Co., Inc., 1977; hardcover, 2,165 pages. The next step up from a home medical guide written for the general public is the *Merck Manual*. This book is a bonanza of information on the diagnosis and treatment of almost anything that can happen to the human body. Although it is written for the medical profession and therefore contains a certain amount of medical terminology, it can be put to good use by anyone using a small medical dictionary (see below). It is compact, thumb-indexed, very complete, and a real asset if you ever have a health problem. While you won't find the *Merck Manual* on the best-seller rack, most large book-

stores do carry it and any bookstore can order it. Your library probably has a copy in the reference section.

The New American Medical Dictionary and Health Manual, by Dr. Robert E. Rothenberg; published by New American Library, 1975; paperback, 496 pages. This book is useful on its own or as a companion volume to the *Merck Manual*. It is really two books in one. The first section is a complete dictionary devoted to medical terms which are defined in easy-to-understand language. The second section is loaded with health information, including vaccination and immunization schedules, contagious diseases and their incubation periods, blood pressure tables, temperature, pulse and respiration rates for different age levels, common medical abbreviations, and much more.

Physicians' Desk Reference (PDR), published by Medical Economics Book Division, Box 58, Oradell, N.J. 07649; hardcover, about 2,000 pages. This manual contains comprehensive, up-to-date, understandable information on any drug a doctor can prescribe for you. Included, among other things, are the uses for each drug, dosage amounts, precautions, and side effects. It's worthwhile to check any drug prescribed for you and to ask your doctor if you have questions, as mistakes and misunderstandings do occur. A new volume of the PDR is published at the beginning of each calendar year with all the latest information on every prescription drug approved for use in the U.S. The book is not carried in bookstores; to order a copy, write to Medical Economics Book Division and request an order form. Since physicians reorder this book each year, you can sometimes obtain a copy by asking your doctor or the local hospital for last year's copy. Libraries also carry this book as a reference volume.

How To Be Your Own Doctor—Sometimes, by Dr. Keith Sehnert; published by Grosset and Dunlap, 1976; paperback, 353 pages. This book is a good starting place for people interested in medical self-help. Dr. Sehnert believes in the concept of the "activated patient," a person trained in basic clinical skills and able to participate in his or her own health care. This book teaches you to use basic medical tools such as a blood pressure cuff and an otoscope. The medical guide in the last section of the book gives excellent directions for dealing with common illnesses, accidents, and emergencies.

Medical Self-Care Magazine, edited by Tom Ferguson, M.D.; published by Medical Self-Care, P.O. Box 717, Inverness, CA. 94937. This quarterly magazine is the best on-going source of information on medical self-care subjects. Each issue contains articles on basic paramedic skills, medical information access, and how to become more involved with your own health care. Also included are reviews of the best current medical books.

DISASTERS

Besides the resources listed in this section, you may find it informative to research disasters that have occurred in your area. The history of local disasters makes for interesting reading and will help you anticipate what may happen again.

In Time of Emergency, from the Defense Civil Preparedness Agency (DCPA), 2800 Eastern Blvd. (Middle River), Baltimore, Maryland, 21220. A free paperback, 92 pages. This is the official government pamphlet on what to do in a disaster. Over half the booklet is devoted to nuclear attack, with the rest briefly covering

natural disasters. You can often obtain this pamphlet free from your county government; if not, write to the DCPA.

The Great International Disaster Book, by James Cornell; published by Charles Scribner's Sons, 1976; hardcover, 382 pages. This book is a virtual encyclopedia on disasters. It presents comprehensive coverage of every type of natural and manmade catastrophe from avalanches to volcanoes. Each section thoroughly covers a different disaster, including the strange and interesting stories of the more important incidents that have occurred during the course of history. The impact of disasters on society, along with ways to prepare for and prevent them, are described. Many pictures throughout the book add to its completeness. The library may have a copy you can check out.

Disaster Handbook, by Solomon Garb, M.D. and Evelyn Eng, R.N.; published by Springer Publishing Co., 1969; hardcover, 248 pages. Although written primarily for doctors and nurses, this book contains information of interest to anyone who is in a leadership position or who is responsible for emergency preparedness. There are extensive sections on disaster management and disaster nursing, and advice on rescue efforts for most types of manmade and natural emergencies. Many libraries have a copy of this book.

INFORMATION FROM THE GOVERNMENT

The federal government puts out a variety of informational material on disasters and disaster planning. You can write to these agencies and ask for a listing of titles on this subject:

Defense Civil Preparedness Agency
2800 Eastern Blvd. (Middle River)
Baltimore, MD. 21220

National Oceanic and Atmospheric
 Administration
Silver Spring, MD. 20910

United States Government Printing Office
Superintendent of Documents
Washington, D.C. 20402

APPENDIX 2

Kids, Schools and Disaster

Our children spend many hours each day at school. Their safety and security during this time is of paramount importance to both parents and educators. Every school must have a well-thought-out plan of action to meet unexpected emergencies, and a staff trained to put this plan into effect. As a parent, do you know what plans have been made at your child's school in case of an emergency? If you are an educator, do you know what your responsibilities are in an emergency and are you prepared to handle such a situation with confidence? The answer to these questions should be a firm "yes." Unfortunately, this is all too often not the case.

Schools need to be well prepared to cope with a disaster. This is especially important in regions where disasters such as tornadoes or earthquakes may strike with little or no warning. Beyond adequate planning and preparation lies the responsibility of schools to train their students in basic disaster preparedness and emergency self-help, as most students can expect to face several emergencies during their lifetime.

This appendix will help lay the foundation for developing good emergency planning at a school. It also provides ideas on how to teach

emergency preparedness at any grade level. At first glance the material covered may appear primarily designed for educators, but parents and children will also reap the benefits. As a parent, please don't hesitate to use this information to encourage your child's school to improve its emergency planning or to implement disaster preparedness instruction in the curriculum.

DISASTER PLANNING FOR YOUR SCHOOL

The primary responsibility of any school in an emergency is to provide the maximum protection possible for the students and staff. School administrators need to assess what kinds of natural or man-made disasters are likely to occur and what can be done at their school for prevention or protection. The basis for how well a school functions in an emergency can be summed up in one word: planning. Without it, emergency management becomes an extremely difficult undertaking.

GUIDELINES FOR DEVELOPING A DISASTER PLAN

Every school needs to develop a disaster plan tailored to its circumstances. The size of the school, its location, the type of potential disasters, and the availability of emergency services all affect the details of the plan. There are however, some common characteristics inherent in all plans:

1. *Community Involvement*—Plans must be developed and coordinated within the scope

of the total community. Ultimately, the plan should incorporate the combined efforts of educators, parents, and relevant government and civic agencies. Widespread input guarantees a more effective plan and insures that all avenues of assistance and cooperation are utilized.

2. *Assigned Responsibility*—The plan needs to outline where responsibility lies in an emergency. Leadership positions at all levels must be defined and specific people designated to fill them. Provision should also be made for alternates to fill these positions if the assigned persons are absent.

3. *Training And Practice*—Training for both school staff and students in basic emergency preparedness is necessary to make any plan functional. This includes such things as first aid training, a fire extinguisher demonstration, etc. Routine drills for protection against fire, tornadoes, earthquakes and other disasters need to be carried out periodically. This helps staff and students respond with confidence in a real emergency.

4. *Periodic Updating*—The best of disaster plans become obsolete with time if they are not frequently updated. When revising the plan, make sure new staff members understand their responsibilities.

5. *Supplies*—Purchase needed emergency supplies and have them checked regularly.

PREPARING A SCHOOL FOR AN EMERGENCY

Once the guidelines of a disaster plan have been drawn up, attention needs to turn to the spe-

cifics of preparing the school to meet an emergency. Some major areas of concern a school needs to examine are:

Notice To Parents At the beginning of every school year send a notice home with each student outlining the emergency procedures the school plans to follow. It should be made clear under what conditions students will be kept at school and when they will be sent home. Parents also need to know how they can get information about their children in an emergency. Include appropriate telephone numbers as well as the call letters and frequency of any local radio station designated to broadcast emergency bulletins. Knowing what to expect and how to get information on what is being done makes an emergency less nerve-wracking for parents and faculty.

The notice should enlist parental support for the school's emergency procedures in these ways:

1. Ask parents to discuss the school's emergency plans with their children. This helps to reinforce what students have already learned at school.

2. Remind parents that the school must always have their correct telephone number and address. In addition, the school needs to have the telephone number of a relative or neighbor where the child could go if the parents were not at home.

3. Encourage parents to improve their own level of emergency preparedness at home. Possessing a battery-operated radio is particularly important as this may be the only way a school district can get word to parents if telephone lines are down.

Emergency Phone Numbers Post an up-to-date list of emergency numbers by every outside line at the school. Keep this list brief, with only key emergency numbers on it. Use the cutout page in Chapter 2 as a model.

Staff Training And Responsibility A meeting should be held at least once a year that focuses on the general procedures the school would adopt in an emergency and the role of each teacher. The importance of accurate record-keeping during an emergency needs to be stressed. All teachers should know the whereabouts of every student they have under their supervision. Also, take a few minutes to walk to each of the main utility shutoffs in the school and demonstrate how they operate.

This is the time to assign various staff members to the specific tasks they are responsible for in an emergency. For the most part, a teacher's primary duty is to supervise his or her students. Other staff at the school site can be utilized for the following important jobs:

1. Coordinate first aid (school nurse).
2. Shut off utilities if needed (janitor). As many staff members as possible should know how the utility shutoffs operate.
3. Take charge of food and water (cafeteria manager).
4. Check building safety (janitor or administrator).
5. Communications and records (administrator and secretary).
6. Organize games and activities for students to pass the time (P.E. director or individual teachers).

In addition, distribute a map of the school to each teacher with the information listed below:

1. Location of exit routes from all classes in each building.
2. Location of all outdoor assembly sites in case buildings must be evacuated.
3. Location of all utility shutoff valves and switches.
4. Location of all emergency equipment such as fire extinguishers, first aid kits, radios, emergency lights and tools.
5. Location of all sources of emergency water.

Emergency Equipment

In conjunction with staff training, every school needs to have some basic equipment for dealing with an emergency. Some of the more important items are:

1. *Communication Equipment*—It is vital to communicate to hundreds of students what is expected during an emergency. Normal methods such as the public address system or bells won't work if the electricity fails. The situation becomes even more difficult if the building must be evacuated. Battery-operated megaphones offer the best source of effective and reliable communication. In large schools, it is worthwhile to have a battery backup for the public address system. Walkie-talkies or student messengers are also useful on a large campus.
2. *First Aid Supplies*—The school nurse or another qualified person should periodically check the adequacy of the first aid kits in the school along with other supplies such as blankets or stretchers.

3. *Radios*—The main office at the school should have at least one good, battery-operated, multiband radio. Additional radios at other strategic points are desirable, especially on a sprawling campus. A weather radio with a warning alarm is very useful in areas with sudden severe storms. It is also a good idea to explore the possibility of setting up a two-way radio communication network between the school and the district office or the local Emergency Operating Center in case phone lines are disrupted. School buses should be equipped with CB radios so the driver can call for assistance if needed.

4. *Lighting*—All schools should have at least a few flashlights for emergency use. More elaborate arrangements, including portable lanterns or standby lighting, are needed where local emergencies have the potential of forcing students to stay overnight at school. Generators for electrical power are usually too costly to justify their purchase.

5. *Tools*—The school should have items such as wrenches, shovels, crowbars, heavy gloves and rope available. Check with the janitor to see if the needed equipment is on hand.

6. *Water Supplies*—Alternative sources of water are necessary if the water service is disrupted while students are at school. Take a survey of where water could be obtained at the school site. It is a wise precaution to store several five gallon containers of water in case of an emergency. Be sure to have a way to purify water at the school. Refer to Chapter 14 for information on finding and purifying water.

7. *Food*—In localities where emergencies such as earthquakes could force students to remain at school for a considerable period of time, thought needs to be given to the question of food. The cafeteria manager should have some contingency plans for this situation. Arrangements can often be made with nearby supermarkets for schools with no cafeteria.

TEACHING DISASTER PREPAREDNESS

What students learn at school can filter home to their parents and raise the general level of preparedness throughout the community. Disaster preparedness and emergency self-help can be taught at almost any grade level, beginning in elementary school. In high school, units can be incorporated into a variety of classes ranging from social science, government and vocational education to health and physical education. Teachers will find that most students, like adults, sense the practicality of learning disaster preparedness and appreciate the feeling of self-reliance it affords them.

Resources For Teachers

There are many different resources upon which you can draw to teach a unit or course on disaster preparedness. You can begin by checking the pamphlets, posters and audio-visual materials that are available through your school district, the local government agency in charge of emergency services and the nearest Red Cross Chapter. Your state government should also have information on this subject.

Printed Material An excellent resource is the "Your Chance To Live" series developed by the federal government for grades 6 through 12. The series includes a 111-page book for students plus a variety of films and other audiovisual materials. The teacher's manual gives detailed lesson plans for each chapter and many suggestions for other activities. The cost for each student book is $2.95; there is a 25% discount for orders over 100. Write to:

> Defense Civil Preparedness Agency
> 2800 Eastern Blvd. (Middle River)
> Baltimore, Maryland 21220

You can also get a large selection of other materials from the U.S. government. Refer to Appendix 1 for more information.

Audio-Visual Materials Most school districts have a collection of films on various man-made and natural disasters. These help to bring emergencies to life for students. Many school districts have the "Your Chance To Live" film series. Each film covers a different type of emergency and can be used alone or in conjunction with the textbooks.

Community Resources Some of the best resources at your disposal are the people in your community. The small effort required to make a few phone calls to line up a series of guest speakers can result in several interesting talks and demonstrations. People who are usually willing to do a presentation include representatives of:

1. *The Fire Department*—Fire safety, the role of the fire department in an emergency, the job of a firefighter, and a fire extinguisher dem-

onstration can all be covered by a speaker from the local fire department. In larger cities, the fire department often has a person specifically for presenting such demonstrations.

2. *An Ambulance Company* — A crew from the local ambulance company is usually willing to take the time to talk about their equipment and discuss their role in an emergency. This can make for a fascinating demonstration, as the sophistication of ambulance rescues over the past two decades has grown enormously.

3. *The Red Cross* — A speaker from the local Red Cross chapter can provide a whole range of information from disaster preparedness to first aid techniques.

4. *The Police Department* — Like fire departments, police organizations in large cities often have speakers available to discuss safety or the role of police in an emergency.

5. *Local Emergency Services* — The director of emergency services for your city or county is another good source of information on emergency preparedness and the role of government in a disaster.

6. *People Who Have Been In A Disaster* — Inviting someone who has been in a major disaster to speak on his experiences lends a sense of realism and interest to the unit.

APPENDIX 3

State Emergency Planning Offices

This appendix lists the name and address of the agency in charge of state emergency planning for each state in the U.S. The agency responsible for your state is the one to contact for specific information on your state's disaster plans and preparations. Many of these agencies also have branch offices in major cities.

STATE EMERGENCY PLANNING OFFICES

State	Emergency Planning Representative	Telephone
ALABAMA	Director, Civil Defense Department State of Alabama Civil Defense Department 64 North Union Street Basement Montgomery, Alabama 36130	(205)832-5700
ALASKA	Director, Alaska Division of Emergency Services State of Alaska 1306 East Fourth Avenue Anchorage, Alaska 99501	(907)272-0594
ARIZONA	Director, Division of Emergency Services 5636 E. McDowell Rd. Phoenix, Arizona 85008	(602) 273-9880

ARKANSAS	Director, Office of Emergency Services Department of Public Safety P.O. Box 1144 Conway, Arkansas 72032	(501) 329-5601 (Conway) (501) 373-4744 (Little Rock)
CALIFORNIA	Director, Office of Emergency Services State of California P.O. Box 9577 Sacramento, California 95823	(916) 421-4990 (916) 445-6231
COLORADO	State Director of Disaster Emergency Services 300 Logan Street Denver, Colorado 80203	(303) 733-2431 Ext. 41
CONNECTICUT	Director, State of Connecticut Military Department-Connecticut Office of Civil Preparedness National Guard Armory 360 Broad Street Hartford, Connecticut 06115	(203) 566-3180 (203) 566-4338
DELAWARE	Director, Division of Emergency Planning & Operations Department of Public Safety P.O. Box C Delaware City, Delaware 19706	(302) 834-4531
DISTRICT OF COLUMBIA	Director, Office of Emergency Preparedness District of Columbia Government Rm. 5009, Municipal Center 300 Indiana Avenue, NW Washington, DC 20001	(202) 727-6161
FLORIDA	Chief, Florida Bureau of Disaster Preparedness Division of Public Safety Planning & Assistance 1720 S. Gadsden Street Tallahassee, Florida 32301	(904) 488-1320
GEORGIA	State Divil Defense Director Civil Defense Division P.O. Box 18055 Atlanta, Georgia 30316	(404) 656-5500

State Emergency Planning Offices

HAWAII	Director of Civil Defense State of Hawaii 3949 Diamondhead Road Honolulu, Hawaii 96816	(808) 734-2195 (808) 734-2161
IDAHO	State Coordinator, Bureau of Disaster Services State Office Building 650 West State Street Boise, Idaho 83702	(208) 384-3460
ILLINOIS	Director, Illinois Emergency Services and Disaster Agency 110 East Adams Street Springfield, Illinois 62706	(217) 782-7860
INDIANA	Director, Indiana Department of Civil Defense and Office of Emergency Planning B-90 State Office Building 100 North Senate Avenue Indianapolis, Indiana 46204	(317) 633-6720
IOWA	Director, Office of Disaster Services Hoover State Office Bldg., Room A-29 Des Moines, Iowa 50319	(515) 281-3231
KANSAS	Program Administrator Division of Emergency Preparedness P.O. Box C-300 2800 S. Topeka Blvd. Topeka, Kansas 66601	(913) 233-9253 (913) 233-7560
KENTUCKY	Director, Disaster and Emergency Services The EOC Building Boone Center State of Kentucky Frankfurt, Kentucky 40601	(502) 564-7815
LOUISIANA	Asst. Secretary, Department of Public Safety Office of Emergency Preparedness P.O. Box 66536, Audubon Station Baton Rouge, Louisiana 70896	(502) 383-6861
MAINE	Director, Bureau of Civil Emergency Preparedness State Office Building Augusta, Maine 04330	(207) 662-6201

MARYLAND	Director, Maryland Civil Defense and Disaster Preparedness Reisterstown Road & Sudbrook Lane Pikesville, Maryland 21208	(301) 486-4422
MASSACHUSETTS	Director, Massachusetts Civil Defense Agency and Office of Emergency Preparedness 400 Worcester Road Framingham, Massachusetts 01701	(617) 875-1381 (617) 237-0200
MICHIGAN	State Civil Defense Director Emergency Services Div. Michigan State Police 111 South Capitol Avenue Lansing, Michigan 48902	(517) 373-0617
MINNESOTA	Regional Director, Division of Emergency Service Department of Public Safety B2—State Capitol St. Paul, Minnesota 55155	(612) 296-2233
MISSISSIPPI	Director, Mississippi Civil Defense Council and Office of Emergency Preparedness P.O. Box 4501 Fondren Sta. 1410 Riverside Drive Jackson, Mississippi 39216	(601) 354-7200
MISSOURI	Director, Disaster Planning and Operations Office P.O. Box 116 1717 Industrial Drive Jefferson City, Missouri 65101	(314) 751-2321
MONTANA	Administrator, Division of Disaster and Emergency Services P.O. Box 4789 Helena, Montana 59601	(406) 449-3034

State Emergency Planning Offices

NEBRASKA	State Director of Civil Defense Nebraska Civil Defense Agency National Guard Center 1300 Military Road Lincoln, Nebraska 68508	(402) 432-7641
NEVADA	Director, Civil Defense & Disaster Agency State of Nevada 2525 S. Carson Street Carson City, Nevada 89701	(702) 885-4240
NEW HAMPSHIRE	Director, New Hampshire State Civil Defense Agency New Hampshire Military Res. #1 Airport Road Concord, New Hampshire 03301	(603) 271-2231
NEW JERSEY	State Director of Civil Defense State Police Headquarters P.O. Box 7068 W. Trenton, New Jersey 08625	(609) 882-2000 Ext. 201 (609) 292-3824
NEW MEXICO	Director of Office of Civil Emergency Preparedness Dept. of Military Affairs P.O. Box 4277 Sante Fe, New Mexico 87501	(505) 982-3841
NEW YORK	Chief of Staff to the Governor New York Division of Military and Naval Affairs Public Security Building State Campus Albany, New York 12226	(518) 457-6966
NORTH CAROLINA	State Director, Division of Civil Preparedness Administration Building 116 W. Jones Street Raleigh, North Carolina 27611	(919) 733-3867

NORTH DAKOTA	State Director, North Dakota Disaster Emergency Services P.O. Box 1817 Bismarck, North Dakota 58505	(701) 224-2111
OHIO	Director of Ohio Disaster Services Agency 2825 W. Granville Road Worthington, Ohio 43085	(614) 889-7150
OKLAHOMA	Director, Oklahoma Civil Defense Agency Will Rogers-Sequoyal Tunnel P.O. Box 53365 Oklahoma City, OK 73105	(405) 521-2481
OREGON	Administrator, Emergency Services Division Oregon State Executive Department 8 State Capitol Salem, Oregon 97310	(503) 378-4124
PENNSYLVANIA	Director, PA Emergency Management Agency Room B-151, Transportation and Safety Building Harrisburg, PA 17120	(717) 783-8150
RHODE ISLAND	Director of Defense Civil Preparedness Agency State House Providence, RI 02903	(401) 421-7333
SOUTH CAROLINA	State Director of Disaster Preparedness 1429 Senate Street Columbia, SC 29201	(803) 758-2826
SOUTH DAKOTA	Administrative Services Officer, Division of Emergency and Disaster Services State Emergency Operations Center Pierre, South Dakota 57501	(605) 773-3231
TENNESSEE	Director of Civil Defense and Emergency Preparedness Military Dept. of Tennessee Tennessee EOC, Sidco Dr. Nashville, Tennessee 37204	(615) 741-5181

State Emergency Planning Offices 237

TEXAS	State Coordinator, Div. of Disaster Emergency Svcs. Texas Dept. of Public Safety Box 4087, N. Austin Sta. Austin, Texas 78773	(512) 452-0331 Ext. 295
UTAH	Director, Utah State Office of Emergency Services State of Utah P.O. Box 8100 Salt Lake City, Utah 84108	(801) 533-5271
VERMONT	Director, Civil Defense Division Department of Public Safety Redstone Montpelier, Vermont 05602	(802) 828-2144
VIRGINIA	State Coordinator of Emergency and Energy Services Virginia Office of Emergency and Energy Services 310 Turner Road Richmond, Virginia 23225	(804) 745-3305
WASHINGTON	Director, Department of Emergency Services State of Washington 4220 East Martin Way Olympia, WA 98504	(206) 753-5255
WEST VIRGINIA	Director, Office of Emergency Services 806 Greenbrier Street Charleston, West Virginia 25311	(304) 348-5380
WISCONSIN	Director, Office of Emergency Government Hill Farms State Office Building 4802 Shebygan Ave. Madison, Wisconsin 53702	(608) 266-3232
WYOMING	Program Manager, Wyoming Disaster and Civil Defense Agency National Guard Armory 5500 Bishop Blvd. Cheyenne, Wyoming 82201	(307) 772-9566
AMERICAN SAMOA	Commissioner of Public Safety Gov't of American Samoa Pago Pago American Samoa 96920	633-4416

CANAL ZONE	Civil Defense Officer Canal Zone Government P.O. Box 451 Balboa Heights, Canal Zone	52-3370
COMMON- WEALTH OF THE NORTHERN MARIANA ISLANDS	Civil Defense Coordinator Office of the Governor Saipan, Mariana Islands ISL96950	TTPI6407/08
COMMONWEALTH OF PUERTO RICO	Director, Office of Preparedness and Defense Commonwealth of Puerto Rico P.O. Box 5127 Puerto de Tierra Station San Juan, Puerto Rico 00906	(809) 724-0124
GUAM	Director of Civil Defense P.O. Box 2877 Agana, Guam 96910	72-6237
TRUST TERRITORY OF PACIFIC ISLANDS	Disaster Control Officer Office of the High Commissioner Trust Territory of the Pacific Islands Saipan, Mariana Islands 96950	(315) 322-1110 x9367
VIRGIN ISLANDS	Director, Office of Civil Defense and Emergency Services Office of the Governor P.O. Box 839, Charlotte Amalie St. Thomas, Virgin Islands 00801	(809) 774-2244

INDEX

Advanced First Aid and Emergency Care, 214
Advanced First Aid and Emergency Care class, 215
Artificial respiration, 197-200
Automobile. *See* Car

Batteries, 26-29, 35
 flashlight, 26
 prolonging life of, 27-28
 radio, 35
 recharging, 29
 storage of, 28-29
Berkow, Robert, 216
Blackouts, 147-152
 conserving electricity during, 149-150
 electrical lines down, 152
 preparation for, 149
 protection during, 150-152
Bleeding, 200-203
Blizzard. *See* Winter storms
Brown, Robert E., 214
Brush fire. *See* Forest fire
Burns, 205-206
Butane. *See* Liquefied petroleum

Camille, Hurricane, 89-91
Candles, 30-31
Car, 60-62, 81-86, 192-193
 emergency equipment, 81-84
 emergency travel, 84-86
 fire, 61-62
 fire extinguisher, 60
 first aid kit, 192-193
 snowbound, 85
 stuck, 86
Cardiopulmonary resuscitation class, 215-216
Choking, 199-200
Circuit breaker boxes, 44-45
Cold weather protection, 164-169
Cornell, James, 219
Cuts, 206-207

Defense Civil Preparedness Agency, 145, 218, 220, 229
Dickey, Esther, 72

Dictionary of Symptoms, A, 216
Disaster Handbook, 219
Disaster preparedness, 3-10
 basics of, 6-8
 emergency supplies, 7-8
 general preparations, 9
 teaching, 228-230
Disaster resources, 218-220
Disease prevention, 173-176
Driving in an emergency, 84-86

Earthquakes, 122-134
 aftermath of, 128-130
 areas subject to, 124
 preparing for, 124-126
 protection from, 127-128
 Richter Scale, 131-132
 tsunamis, 132-134
Electric lines down, 152
Electrical shutoff, 42-46
Emergency Broadcast System, 32-33
Emergency Information Card, 16-17, 23
Emotional reactions, 179-185
 control of stress, 183-185
 sequence of reactions, 180-182
Evacuation, 76-86
 planning, 76-81
 what to take, 79-81
 where to go, 78-79

Fallout, 138, 141-146
 decay time, 143
 effects on food and water, 146
 shelters, 143-146
Family Food Stockpile for Survival, 74
Ferguson, Tom, 218
Fire, 111-121
 car, 61-62
 and children, 116
 dangers of, 112
 escape from, 112-116
 extinguishing, 116-117
 family escape plan, 115-116
 forest, 119-121
 high-rise building, 114-115
 prevention, 118-119
 structural, 112-114
 types of, 56-57

Index 241

Fire extinguishers, 55-64
 car, 60
 demonstrations, 63-64
 home, 59-60
 replacement of, 62
 types of, 57-59, 62-63
 use of, 60-62
First aid, 194-210
 artificial respiration, 197-200
 bleeding, 200-203
 burns, 205-206
 checking a victim, 195-197
 choking, 199-200
 cuts, 206-207
 fractures, 203-205
 frostbite, 166-167
 heart attack, 207-208
 heat cramps, 171
 heat exhaustion, 171
 heatstroke, 170
 hypothermia, 165-166
 infection, 206-207
 lightning victim, 101
 mouth-to-mouth resuscitation, 197-198
 shock, 208-209
 smoke inhalation, 117-118
 stomach upset, 209
First aid kits, 189-193
 car, 192-193
 home, 190-192
First aid resources, 213-216
Flash floods, 106-107
Flashlights, 25-29
 batteries, 26
 emergency use of, 27-28
 types of, 26-27
Floods, 103-106
 aftermath of, 105-106
 areas subject to, 104
 preparing for, 104-105
 See also Flash floods
Food in an emergency, 74, 176-178
Food storage, 69-74
 long-term, 71-73
 short-term, 69-71, 74
Forest fire, 119-121
Fractures, 203-205

242 Just in Case

Frostbite, 166-167
Fuse boxes, 45-46

Garb, Solomon, 219
Gas shutoff, 46-49
Gomez, Joan, 216
Grass fire. *See* Forest fire
Great Chicago Fire, 111
Great International Disaster Book, The, 219
Green, Martin I., 214
Heart attack, 207-208
Heat, 170-172
Heat cramps, 171
Heat exhaustion, 171
Heatstroke, 170
Heavy weather. *See* Storms
Help in an emergency, 11-23
 calling for, 11-16
Hip Pocket Emergency/Survival Handbook, 214
How To Be Your Own Doctor—Sometimes, 218
Hurricanes, 92-96
 aftermath of, 95
 areas subject to, 93
 hurricane warning, 93
 hurricane watch, 93
 mobile homes and, 95-96
 preparing for, 93-94
 what to do during, 94-95
Hypothermia, 165-166

Infection, 206-207
In Time of Emergency, 218

Landslides, 107-110
 areas subject to, 108-109
 protection from, 109-110
 types of, 107-108
Lanterns, 29-30
Lighting, emergency, 25-31
Lightning, 100-101
Liquefied petroleum shutoff, 49

Medic Alert Foundation International, 17
Medical identification tags, 17
Medical Self-Care Magazine, 218
Medical self-help resources, 216-218
Merck Manual of Diagnosis and Therapy, The, 216

Index

Mobile homes, 67, 95, 98, 124
Mormon Church, 72
Mouth-to-mouth resuscitation, 197-198

National Oceanic and Atmospheric Administration (NOAA), 33, 220
National Weather Service, 34, 97, 102, 104, 106
New American Medical Dictionary and Health Manual, The, 217
New York blackout, 147-148
Nuclear accidents, 136-137
Nuclear disaster, 135-146
Nuclear weapons, 137-138, 141-146

Oil-burning furnace shutoff, 49-50

Passport to Survival, 72
Peshtigo Fire, 111
Physicians' Desk Reference (PDR), 217
Power failure. *See* Blackouts
Propane. *See* Liquefied petroleum
Protecting Mobile Homes from High Winds, 95
Protection in the Nuclear Age, 145

Radiation, 138-146
 effects of, 138-140
 measurement of, 139-140
 protection from, 140-146
 sickness, 139
Radio, 32-39
 batteries, 35
 types of, 34-37
 use in an emergency, 36-37
Resources, 213-220
Richter Scale, 131-132
Roentgens, 139-140
Rothenberg, Robert E., 217

San Fernando Earthquake, 122-123
Schools, 221-230
 disaster planning for, 222-228
 emergency equipment for, 226-228
 parents' role in disaster planning, 224
 staff training, 225-226
 teaching disaster preparedness, 228-230
Sehnert, Keith, 218
Shelter, emergency, 78-79, 163-164
Shock, 208-209

Sigh of Relief, A, 214
SKYWARN, 97
Smoke detectors, 64-68
 ionization chamber, 65-66
 photoelectric, 67
 placement of, 67
 replacement of, 67-68
Smoke inhalation, 117-118
Standard First Aid class, 215
Standard First Aid class (Multi-Media System), 215
State emergency planning offices, 231-238
Stomach upset, 209
Storms, 89-110
 general preparations for, 91-92
 See also specific types of storms

Telephone, 11-16
 cutout page for emergency phone numbers, 19, 21
 in a disaster, 15-16
 making an emergency call, 11-15
Three Mile Island, 78, 135-136
Thunderstorms, 99-101
Tidal wave. *See* Tsunamis
Toilets, temporary, 174-175
Tornadoes, 96-99
 aftermath of, 99
 areas subject to, 96-97
 preparing for, 97-98
 shelter from, 98-99
 tornado warning, 98
 tornado watch, 98
Trailers. *See* Mobile homes
Tsunamis, 132-134

U.S. Government Printing Office, 74, 95, 220
Utility shutoffs, 40-53
 circuit breaker boxes, 44-45
 electrical shutoff, 42-46
 fuse boxes, 45-46
 gas shutoff, 46-49
 liquefied petroleum shutoff, 49
 oil-burning furnace shutoff, 49-50
 utility shutoff cutout page, 51, 53
 water shutoff, 41-42
Wall lights, 31
Waste disposal, 174-175

Water, 155-162
 contamination of, 156
 emergency requirements for, 155-156
 emergency sources of, 159-162
 purification methods, 156-159
 storage, 74-75
Water shutoff, 41-42
Weather Radio Network, 33-34, 37-39
Wind chill factor, 164-165
Winter storms, 102-103
 blizzard warning, 102
 preparing for, 102-103
 severe blizzard warning, 102

Your Chance To Live, 229

Author John Moir is an emergency medical technologist, first aid instructor, and consultant on disaster preparedness. His interest in his field grew out of first-hand experiences: first with an Air Force weather unit during Hurricane Camille, and then as a newspaper reporter covering the San Fernando Valley earthquake of 1971. Mr. Moir lives with his wife in Santa Cruz, where he teaches a course in disaster preparedness and serves on the board of directors of the Red Cross.